Canyon Spirits

Canyon Spirits

Beauty and Power in the Ancestral Puebloan World

photographs by John L. Ninnemann

essays by Stephen H. Lekson *and*
J. McKim Malville

foreword by Florence C. Lister

University of New Mexico Press Albuquerque

LIBRARY OF CONGRESS CATALOGING-IN-PUBLICATION DATA

Ninnemann, John L.
 Canyon spirits : beauty and power in the ancestral Puebloan world /
John L. Ninnemann, Stephen H. Lekson, J. McKim Malville ;
foreword by Florence C. Lister.
 p. cm.

 ISBN 0-8263-3241-2 (pbk. : alk. paper)

 1. Pueblo Indians—Antiquities. 2. Pueblo astronomy.
3. Southwest, New—Antiquities.
4. Pueblo Indians—Antiquities—Pictorial works.
5. Pueblo astronomy—Pictorial works.
6. Southwest, New—Antiquities—Pictorial works.
I. Lekson, Stephen H.
II. Malville, J. McKim. III. Title.
 E99.P9.N56 2004
 978.9'01—DC22

 2004020186

All photographs, John L. Ninnemann
Book design and type composition, Kathleen Sparkes
Printed in China by Everbest Printing Company, Ltd.

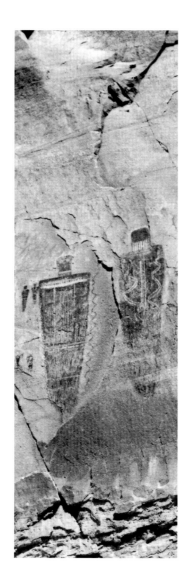

Dedicated to our wives

Laura, Cathy, and Nancy

for their unfailing patience
and inspiration.

☾

Contents

Foreword ☾ ix
 Florence C. Lister

Introduction ☾ 1
 John L. Ninnemann

GALLERY ONE
 Cedar Mesa ☾ 13
 Photographs and Reflections John L. Ninnemann

Anasazi Pueblos of the
 Ancient Southwest ☾ 25
 Stephen H. Lekson

GALLERY TWO
 Grand Gulch and the
 San Juan River ☾ 55
 Photographs and Reflections John L. Ninnemann

Ancient Space and
 Time in the Canyons ☾ 65
 J. McKim Malville

GALLERY THREE:
 Protected Places ☾ 87
 Photographs and Reflections John L. Ninnemann

Photo Details ☾ 99

About the Authors ☾ 113

Foreword

Florence C. Lister

History begins with the written word. For the native peoples of the northern Southwest, it began in 1540 when the scribe accompanying the Spanish Coronado *entrada* mentioned them for the first time and called them Pueblo Indians because they lived in villages. Through use, this became their proper name in the records. By 1540 the ancestors of some of them had been gone from the Four Corners country, a hundred and more miles to the north and west, for two and a half centuries. They only remembered those relatives far removed by time and distance through the haze of legends passed orally from generation to generation. Neither the newly designated historic Pueblo Indians nor the prehistoric Ancestral Pueblos had written languages through which they defined themselves and their worldviews.

Scientists judging the prehistoric branch of this civilization now have reconstructed its material culture—homes and the hardware of daily life—in infinite detail. This has been accomplished because of the basic universality of such artifacts and the array of technological refinements achieved over the last century. But when the researcher ventures into the intangible anthropological aspects of culture, such as social, political, religious, or economic structures, he is apt to step into intellectual quicksand because of lack of documentation.

Observations of current practices in these matters among the various existing Pueblo tribal entities generally are not productive in terms of understanding the mores of former days. There are obvious pitfalls in assuming that the past was analogous to the present. It is a regrettable blind spot in the discipline that archaeologists only now consult Native Americans about their perceptions of their passage through the ages, but, as well intentioned as those efforts at meaningful interaction are, often the versions put forth by these peoples do not coincide with archaeological fact. Moreover, informants understandably decline to discuss sacred subjects.

Some scholars argue that the rock art left on craggy canyon faces, the polychromatic murals painted on kiva walls, and the geometric and naturalistic patterns laid on ceramic vessels were a form of written language in being messages to the spirit world. To those outside this cultural context, translations of the messages are uncertain at best.

So what was the tongue that the Pueblos failed to inscribe? Present day Pueblo groups speak four languages, which suggests roots in diverse ethnicities among forebears. Students of this cultural expression as a whole now believe that thousands of years ago, Archaic bands, from whom the Pueblos eventually evolved, converged on the Colorado Plateau from many directions carrying with them

varied characteristics that probably included language. Quite possibly language distinctions were perpetuated and passed on to the prehistoric and the later historic Pueblos. Could it be that those Ancestral Pueblos who lived in Chaco Canyon or the reaches of Kayenta spoke languages not understandable to those who dwelt in the northern San Juan region? Whatever the circumstances, it is our loss that we know nothing of the ancient songs, music, stories, or rituals preserved through speech. What were the orally transmitted tribal wisdoms guarded by the elders?

What is known is that, some possible ethnic differences aside, the Ancestral Pueblos—whether Basketmakers or full-fledged Pueblos according to archaeological terminology—were all of the Southwest Plateau biological stock and they followed the same modes of life. A considerable homogeneity in material culture existed throughout until the eleventh century when regional differences began to appear.

The two following essays are replete with provocative and speculative ideas in these areas of inquiry. Without written confirmation, not all regional archaeologists or archaeoastronomers will agree with all of them. No matter. These seeming unknowables to Euroamerican observers contribute to the mystic quality that envelops Ancestral Pueblo prehistory. That, in turn, stimulates further thought by both professionals and interested lay readers.

The land itself promotes a sense of wonder and mystery. The Colorado Plateau ranges from timberline in the northeast to the deep gorges of the Colorado River in the west. In between great sweeps of broken emptiness is counterpoised surreal topography of naked pinnacles, stony arches, and volcanic necks. Pockets of haunting beauty butt up against those of desolation. Amid all this extraordinary landscape, where relatively few non-Indian people now live, there are scores of tumbled structures once occupied by thousands of Ancestral Pueblo families. Made of rocks, earth, and timbers at hand, their angular silhouettes and coloration make them appear as integral features of the natural surroundings. Bathed in stillness and floating shadows, they resonate with the spirits of the departed, as the title of this book suggests.

To modern eyes, many buildings seem situated in improbable places: in rock shelters, in alcoves stranded high on rugged escarpments with the only means of access being hand and toe holes cut into the sandstone, balanced atop huge isolated boulders, or out in the flats with no tree or water source nearby. This latter scene likely was not as challenging to ancient tribes because of their lack of domestic livestock to eat and trample the vegetational cover and aggravate erosion.

Archaeologists customarily divide the domain occupied by the Ancestral Pueblos into three districts.

That north of the San Juan River, known as the Mesa Verde Province, was the homeland of the largest number of these people because soil, water, and climatic conditions were most conducive to agriculture. Ironically, Chacoans, living in a more arid, resource-deficient zone south of the San Juan River, achieved the highest level of cultural advancement but were the first to leave their territory. So far as is presently known, the earliest group identified as Puebloan (Basketmaker II) and the first attempts at raising corn in the northern Southwest are found in the Kayenta district, also south of the San Juan River and now in the heart of the Navajo Reservation. This was the most sparsely occupied province and in some respects the Ancestral Pueblos there lagged behind their peers in the two other provinces.

To wander through the simple Ancestral Pueblo houses or around less discernible archaeological sites is to appreciate human triumphs involved in coping with varying success for some two thousand years in such a demanding land, where summer rains come as torrents or not at all, where one day the temperature hovers around one hundred degrees and shortly thereafter plunges to zero. The silent vacancy of these ruins suggests failure, but that certainly was not the case.

A combination of unknown forces merely led the Ancestral Pueblos to move elsewhere with their

culture perhaps modified but still intact. That is as
it was when the invading Spaniards first met them at
Zuni, the Hopi mesas, and in the central Rio Grande
valley. The reasons for the exodus from the Four
Corners area, whether it was gradual or abrupt, and
where the emigrants resettled are topics of debate.

The uniqueness of the region and its cultural
resources has inspired a great deal of literature
romanticizing both. This book, aimed for the
general public, counters that trend by presenting
in a non-technical manner the current scientific
interpretations of chronology and more subtle
themes that may have guided the players in this
drama. The striking photographs aptly document
them while capturing the illusive essence of these
remarkable reminders of another less complicated,
but nonetheless taxing, time.

Florence C. Lister
Mancos, Colorado

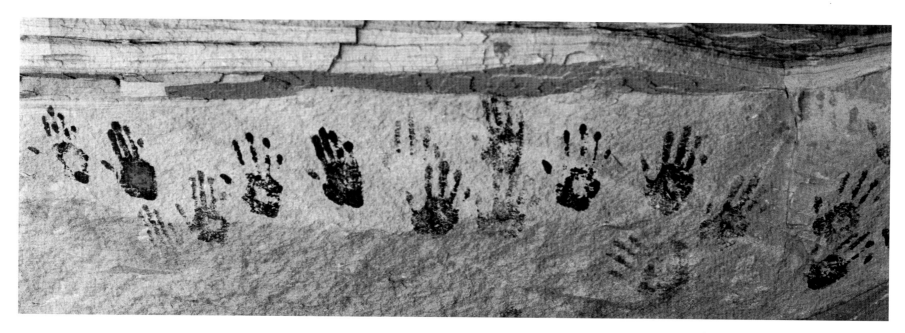

Canyon Registry, White Canyon, Southeast Utah

Introduction

John L. Ninnemann

Hiking the canyon country of the Colorado Plateau on an early summer day is a singular experience. Such walks are often punctuated by the song of the canyon wren, the rasp of the raven, the scurry of the ubiquitous whiptail lizard, and rare but wonderful, adrenaline-releasing encounters with deer, bear, or rattlesnake. The absolute quiet, the smell of the earth and sage, the heat of the high desert sun, the contrasting cool of the canyon, the incredible cerulean blue of the sky; none of these can be described adequately in words. Nor can they even be shown in photographs.

Encountering centuries-old human habitations and bursts of artistic frenzy on the slickrock canyon walls are special pleasures that always raise questions

about the previous residents of this place. Our own modern world of Vibram soles, Powerbars, and the 4-wheel drive that brought us here, is in remarkable contrast to the world of these Ancestral Puebloan people. From our canyon walks, it is easy to romanticize their existence, and picture a primitive, "noble savage" existence; a sanitized, odorless world, free of conflict and disease. A world, unfortunately, free of any real connection with our own human-ness.

Ellen Meloy reflects on this missing perspective in her recent book *The Anthropology of Turquoise.* "The Basketmaker Anasazi had no wheels, no pockets, no identifiable hats, and no lack of ingenuity. They replaced the atlatl—a throwing stick mounted with a stone-tipped dart, used by earlier hunters—with the bow and arrow. For blankets they wove furry strips of rabbit skin with rows of twine. Mineral-based paints

adorned their corded yucca-fiber sandals, some of which had stylish toe loops. They burped, their arms went numb when they slept on them wrong, and they saw their own faces in mirrors of still water. Their pottery was plain gray or painted black on white; their babies were portable. They remembered the past and contemplated their future. They gossiped and dreamed."

What we do know about the "old ones" we have learned by talking with their living ancestors and by studying the structures and everyday items they left behind. The picture that emerges is one of infinite resourcefulness, technical genius, complex social structure, and astronomical sophistication. But the books describing the ancient cultures of the Southwest often relate only dry narrative of geography and dates, rarely giving us a glimpse of the actual lives and the skills and accomplish-ments of the

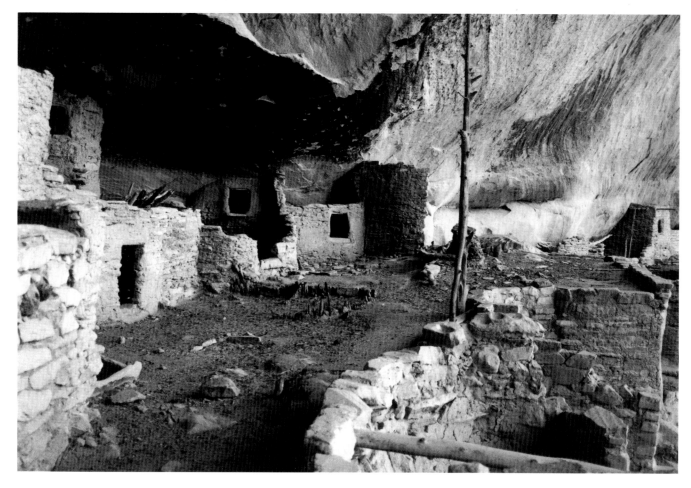

people who lived during these times. Not that the dates and places are unimportant to our understanding, but something significant is missed in the process.

People of distinctly different cultures occupied the southwestern portion of North America during prehistoric times. The literature describing the cultures of the Four Corners region has most often used the term "Anasazi" to label these people.

The term comes from the Navajo language, and can be variously translated as "ancient ancestors," or "ancient enemies," giving an unfortunate connotation to people who, it turns out, were not ancestors or even enemies contemporary with the Navajo people. Today's descendants of the Anasazi are the people of the modern Pueblos, so the term "Ancestral Puebloans" to describe their ancestors, is much preferred.

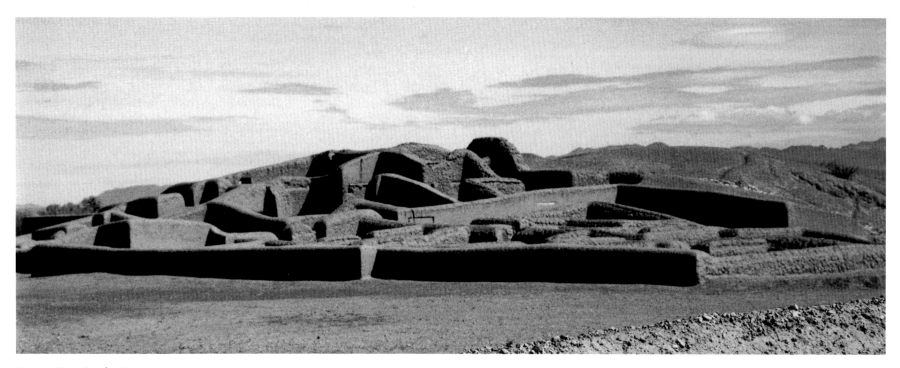

Paquimé, Casas Grandes, Mexico

Geographically, the Ancestral Puebloans occupied a vast area including not only the Four Corners region of what is now the United States, but also extending south, by some estimations, into the Chihuahuan desert to Casas Grandes in what is now Mexico where the great ruin of Paquimé still stands. More than one Ancestral Puebloan culture occupied this high desert area over a period of centuries; cultures that flourished and declined with the availability of limiting resources in this arid and spare land.

Typically, these Puebloan cultures have been divided into Archaic, Basketmaker, and Pueblo designations, with each of these further subdivided into two or more distinct cultural periods. Each of these peoples has left behind unique evidence of their civilization, and interpretation of these cultural remains is challenging and often the subject of heated debate among archaeologists.

The Archaic cultures, divided into Early, Middle, and Late periods, spanned from approximately 6500 B.C. to A.D. 500. It is thought that the Archaic

The Great Gallery, Canyonlands National Park

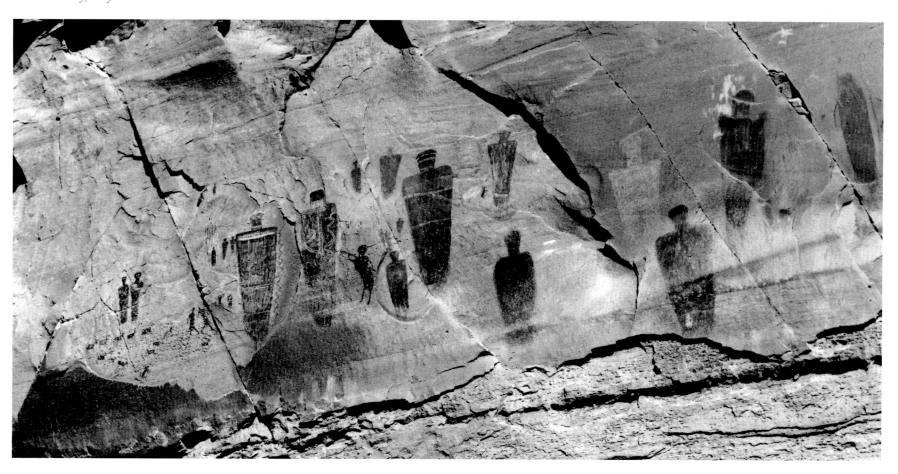

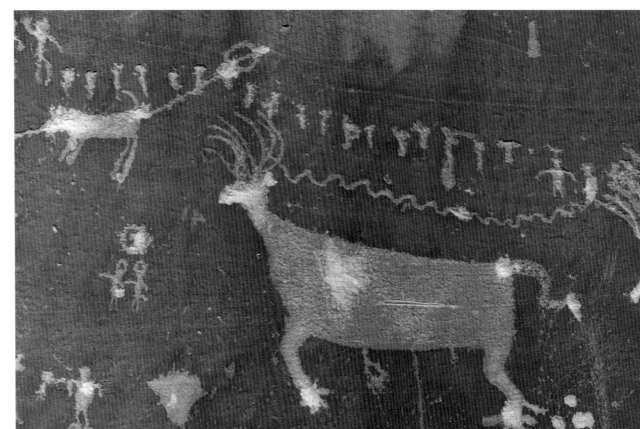

people consisted of roving bands of hunters and gatherers. Little if anything remains of their shelters, but it is known that they were accomplished hunters who used the atlatl and spear to fell their game. The Archaic people have left behind some enigmatic and ghost-like rock art, among which is the famous Great Gallery found in Canyonlands National Park. The pictographs of the Great Gallery include nearly life-sized human figures painted with mineral pigments, then incised with complex designs and symbols.

The Archaic cultures are usually assigned dates of 1500 B.C. to approximately A.D. 750. The Basketmaker II culture (A.D. 50 to A.D. 500), and Basketmaker III culture (A.D. 500 to A.D. 750), each had distinct characteristics. In general, the

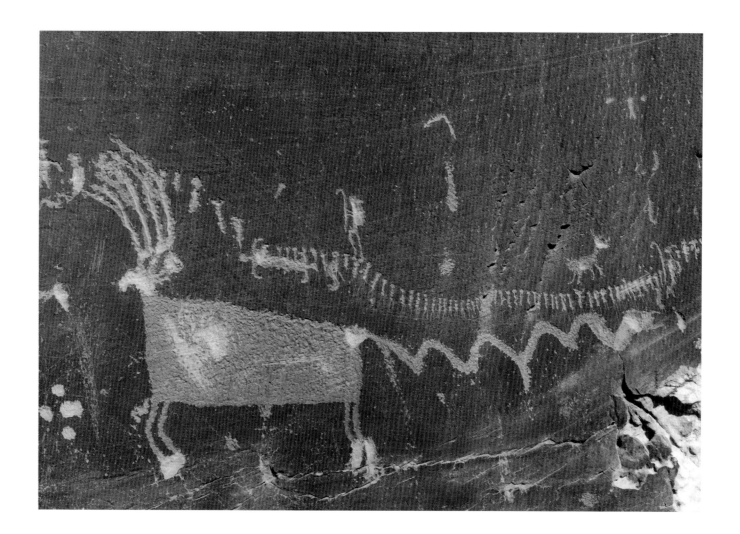

Basketmaker people were farmers of corn and squash, who supplemented this diet by gathering wild fruits and seeds and hunting small game. For the most part, they lived in rock shelters, and later constructed pithouses, hunted with atlatls, made stone and bone tools, wove sandals and baskets, and made cloth out of cotton. Near the end of the Basketmaker period, the people acquired the ability to make pottery, use the bow and arrow, and added beans to the crops that they cultivated. The Basketmakers were accomplished rock artists, and have left us magnificent, detailed examples of their artistry on the mesas and in the canyons of the Southwest. The many petroglyph and pictograph rock art panels suggest much about their lives, beliefs, and their fears, even though the Basketmaker people did not have a written language.

"The Anasazi lived in a land of long, temporary shadows," writes William Calvin in his book *How the Shaman Stole the Moon*. "Some of these moving shadows slowly sweep across rock art. Much has been written about the potential astronomical significance of the art-shadowline combination. Fajada Butte is perhaps the best known of the examples . . ."

Thus we surmise that they had an amazing knowledge of the cosmos, certainly a counting system, and most likely astronomer-priest leaders who guided planting, festivals, and probably much more of daily life. During this period of time, there is also evidence of conflict, an unfortunate artifact of the human condition, usually taking the form of small skirmishes, presumably as the result of competition for life's necessities during times of scarcity.

The Pueblo cultures are divided by approximate dates into Pueblo I (A.D. 750–900), Pueblo II (A.D. 900–1150), Pueblo III (A.D. 1150–1300), and Pueblo IV (A.D. 1300–1540). The living quarters of the Puebloan peoples were generally built above ground, ranging from jacal structures and "unit pueblos" to the magnificent cities of Chaco Canyon and Mesa Verde. While the rock art created by these civilizations is not as refined as that created by the earlier Basketmaker peoples, their architectural accomplishments are truly amazing. The development of the kiva, an underground ceremonial structure, is one of the hallmarks of Pueblo architecture. The kiva, generally thought to be derived from the earlier pithouse structure, is a subterranean room devoted to ceremony and also, some think, to comfortable gathering places for family groups where weaving and other activities appear to have taken place. The many ruins scattered across the Southwest often include "great kivas," which are huge circular structures, characteristic of the Chacoan and later civilizations. The very large masonry structures called "great houses" were another innovation of the Chaco people, often displaying both sophisticated engineering and stonework so beautifully done that it is unmatched by anything found before or since. Chacoan great houses were connected by a system of formal roads, which is particularly remarkable since this civilization possessed neither the wheel nor pack animals. The long period of Chaco's political power (late Pueblo I through Pueblo II) was thought to be a period of relative plenty, and relative peace, sometimes referred to as the *Pax Chaco*. Recent evidence, however, suggests that this peace may have been enforced by carefully orchestrated acts of violence.

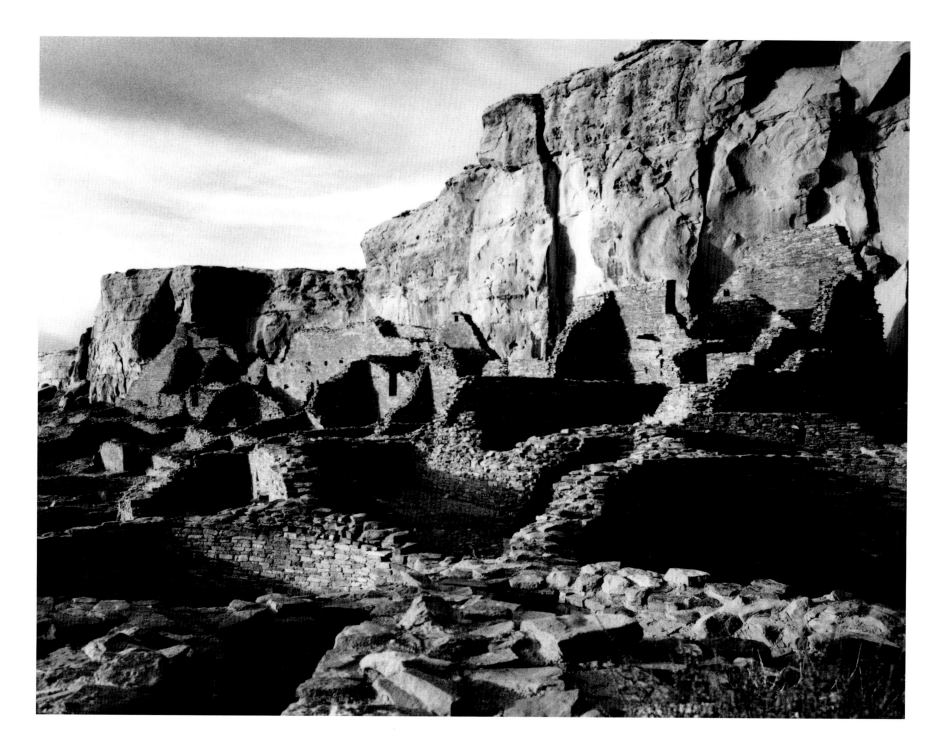

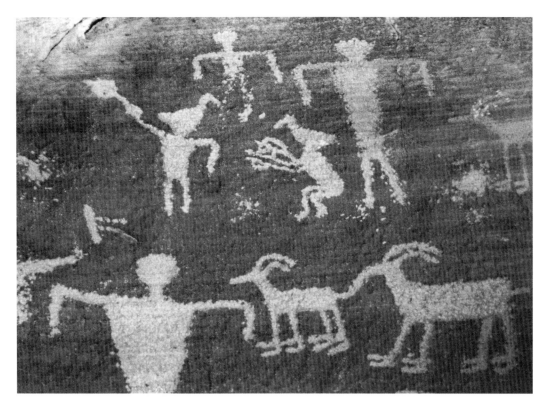

Duckhead petroglyphs, Montezuma Creek Canyon, Utah

Tree ring data show that the weather was fairly predictable in the Southwest through Pueblo I and Pueblo II periods, making cultivation of corn, beans, and squash a reliable source of food for growing populations. By the 1200s, however, the weather had become drier and generally cooler. Seasonal droughts and failing crops in the Southwest are thought to have had a profound effect on the Pueblo III people, which is seen even in the architecture that remains from this period. The center of power shifted away from Chaco Canyon, and widespread violence returned as resources became scarce. People moved closer together and built their living structures in defensive positions with peepholes, protective walls, and limited access. Defensive structures and towers were constructed surrounding springs and other sources of water, emphasizing the importance of this life-limiting resource. The rock art of this period often depicts human figures fighting, and an abundance of shields and weapons. Sometime in the 1300s for an incompletely understood combination of reasons, a exodus of the people from the Colorado Plateau took place.

T. H. Watkins writes: "Over the course of a few decades, then, the land of Southern Utah was left to the wind and the silence, the people who once had called it home leaving behind only the disintegrating ruins of their mesa-top villages and sacred sites, their complicated irrigation systems, their granaries tucked into canyon walls, their cliff dwellings shadowed in the protective, overarching rock, their hundreds of thousands of incisions and paintings—a literature of stone no less eloquent for its still uncoded mystery."

It is these "ruins" then, that provide the physical medium of study to the archaeologist, and the aesthetic inspiration to the artist and photographer. This book is meant to be a partnership of these two, quite different worlds.

The pages that follow represent a nontraditional approach to the ancient cultures of the Southwest. While the beauty of the region is stunning and speaks for itself, a few comments are in order concerning the written word. Here, two well-known experts in southwestern archaeology share their observations of

the accomplishments of the Ancestral Puebloan people. Dr. Stephen Lekson (*The Chaco Meridian: Centers of Political Power in the Ancient Southwest*) discusses the sequence of Puebloan cultures that made the Colorado Plateau their home. Dr. Lekson's focus on the transfer of power and authority from one geographic center to another gives new insight into the very human reasons for these cultural shifts in the ancient world. Dr. Lekson presents a compelling argument to include Paquimé, in what is now northern Mexico, in this sequence of Puebloan civilizations. Dr. J. McKim Malville (*Prehistoric Astronomy in the Southwest*) explores a major focus of power in the ancient Southwest, that of the astronomer-priests and their amazing knowledge of the cosmos. Dr. Malville's unique knowledge of ancient sites and alignments is paired with his ability to explain astronomical events in a compelling and understandable way.

Both Dr. Lekson and Dr. Malville have
introduced new thinking in a field that has many
points of view and frequent scholarly disagreement.
In fact, Lekson's and Malville's interpretations
differ from each other on certain specific points.
Interpretation is indeed a challenge where there is
no written historical record to guide us. But new
ideas and scholarly discourse are important to the
progress of understanding in any field. While the
chapters that follow are meant to stimulate discussion
and speculation, all realize that any interpretation
is likely to be refined as new information is added
to the record.

The photographic plates included with the text
are meant to document and celebrate the beauty
and context of sites, artifacts, and events. The
images presented here were recorded on film using
Hasselblad and Olympus OM cameras with a variety
of lenses and filters. Most photographs were made
using Ilford Delta 100 film and slow shutter speeds
utilizing a tripod. Negatives were developed using
Agfa Rodinal, then printed to Oriental or Ilford fine
baryta fiber-based papers developed in Dektol and
toned with Kodak rapid selenium toner. Final prints
were scanned and digitized to facilitate the printing
of this book.

Special thanks to the staff of the Edge of the
Cedars State Park Museum in Blanding, Utah, especially
Teri Lyn Paul and Deborah Westfall, for allowing me
to photograph their magnificent collections and for
providing the curatorial information.

WORKS CITED:

Calvin, William H. 1991. *How the Shaman Stole the Moon.*
New York: Bantam Books.
Meloy, Ellen. 2002. *The Anthropology of Turquoise.*
New York: Pantheon Books.
Watkins, T. H. 2000. *The Redrock Chronicles.* Baltimore:
The Johns Hopkins University Press.

GALLERY ONE:
Cedar Mesa

Photographs and Reflections
John L. Ninnemann

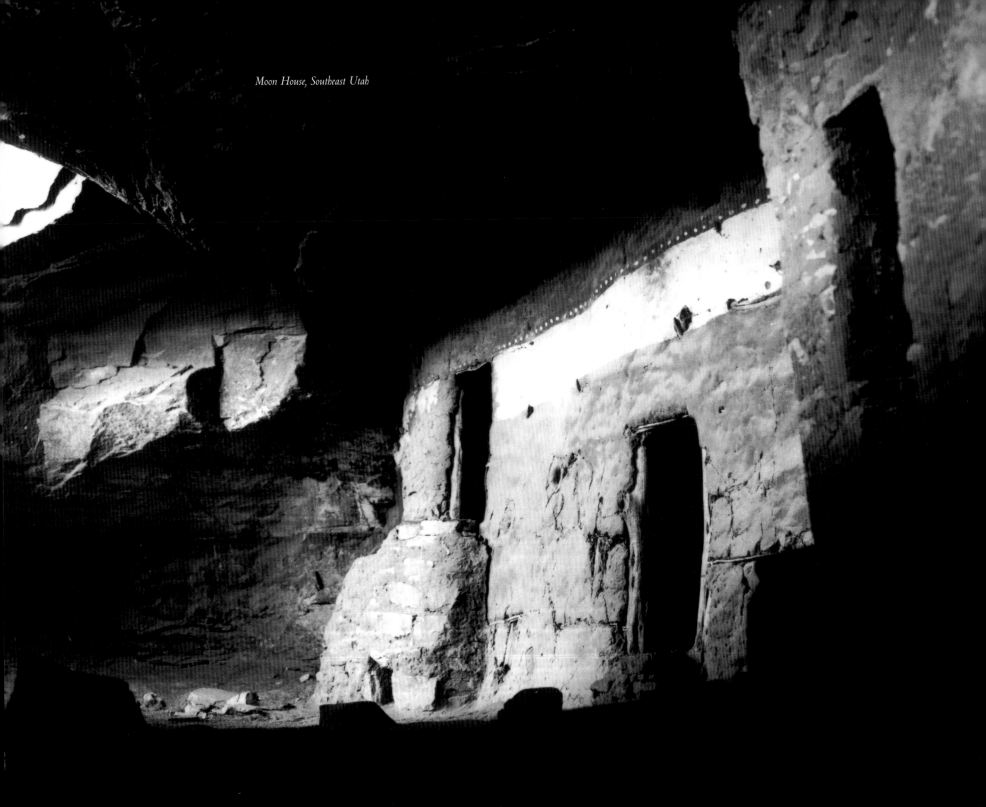

Moon House, Southeast Utah

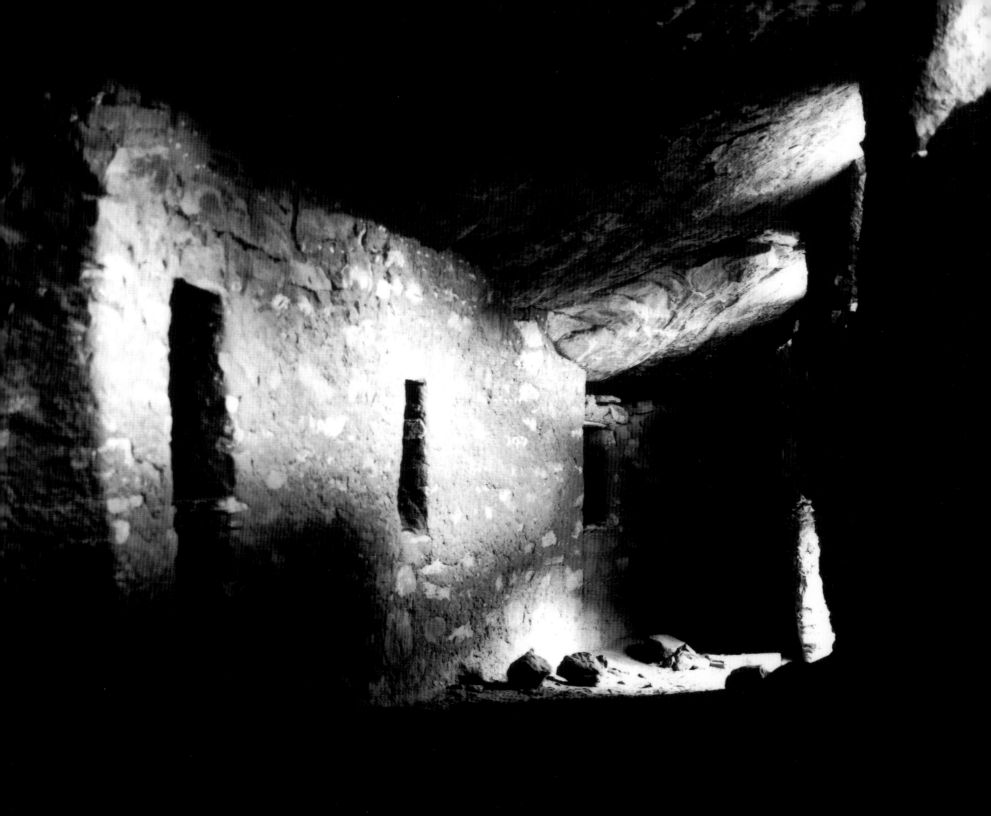

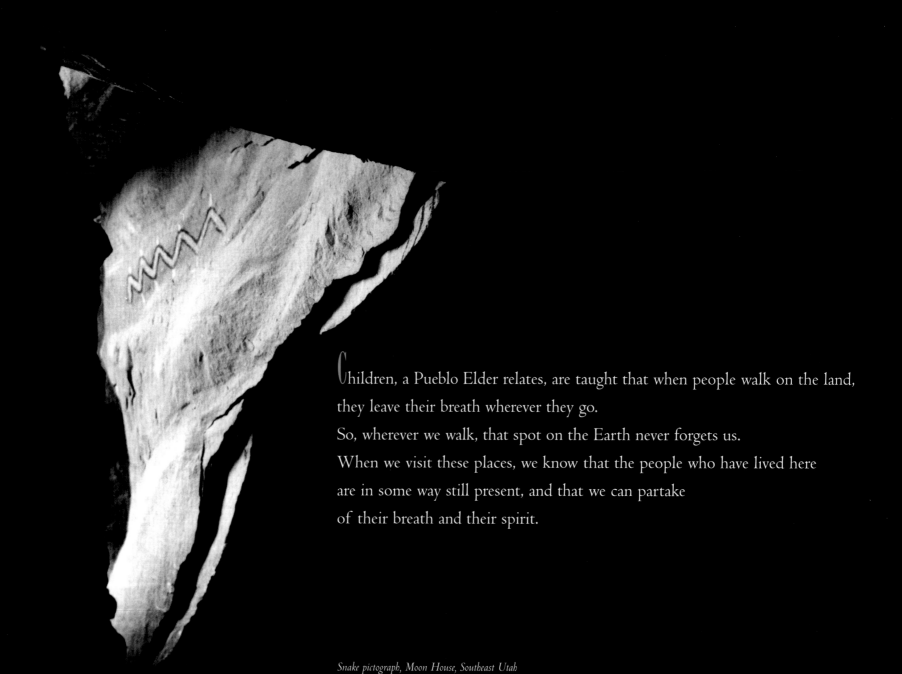

Children, a Pueblo Elder relates, are taught that when people walk on the land,
they leave their breath wherever they go.
So, wherever we walk, that spot on the Earth never forgets us.
When we visit these places, we know that the people who have lived here
are in some way still present, and that we can partake
of their breath and their spirit.

Snake pictograph, Moon House, Southeast Utah

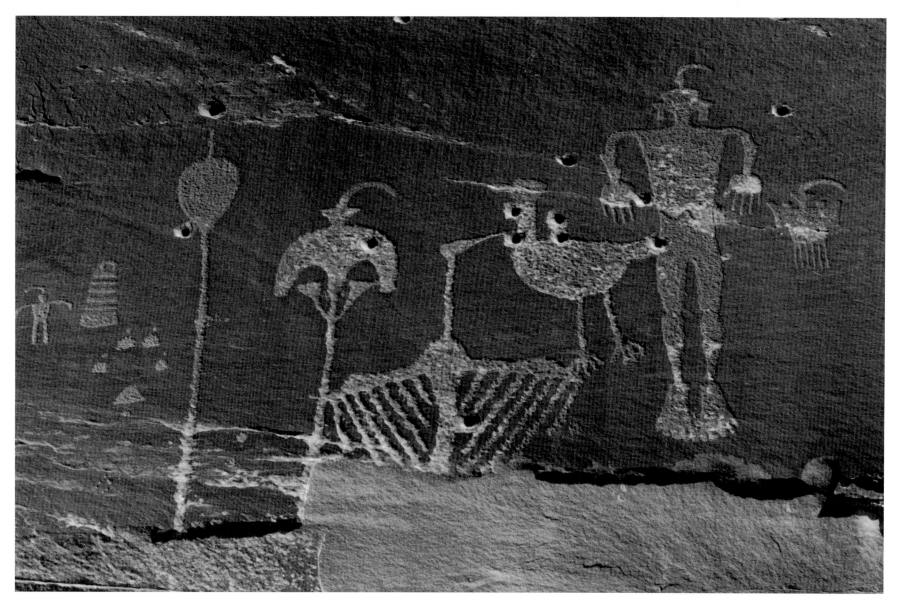

Wolfman petroglyph panel, Southeast Utah

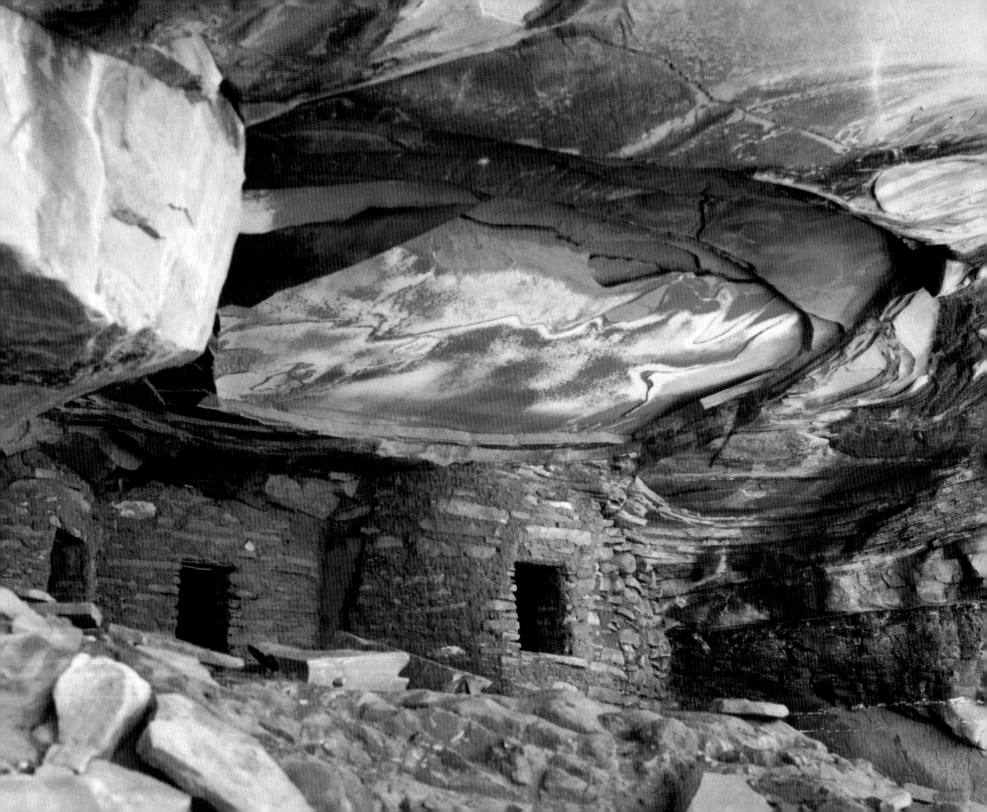

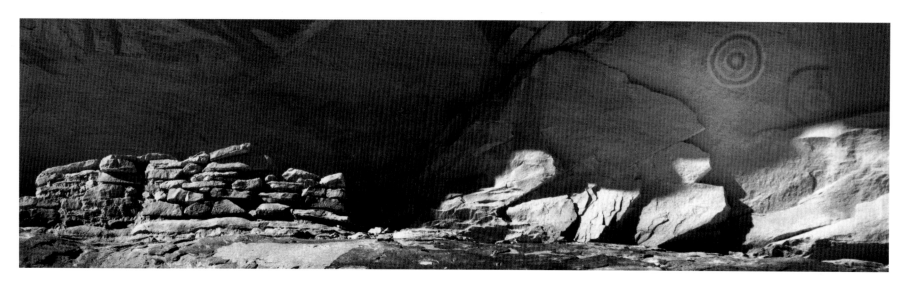

Shield pictographs, Southeast Utah

The stillness is a presence here, at first an unfamiliar companion as I walk.

But with each passing mile, the recent memory of civilization fades,

leaving a canyon-walled world of quiet and beauty.

The empty rooms and rock panels, abandoned by stonemason and artist,

accent the stillness.

I stop, make a photograph, smile, and walk on.

Solitary, but not alone.

Road Canyon Ruin, Southeast Utah

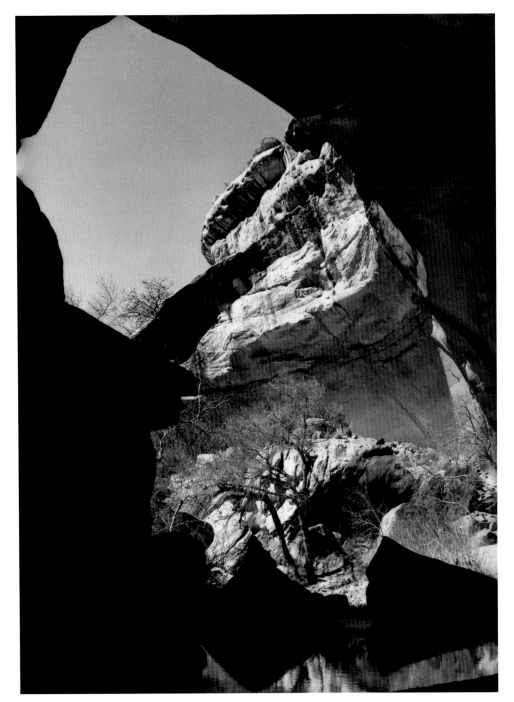

Kachina Bridge, Natural Bridges National Monument

Subtle sounds punctuate my otherwise silent journey.
A brittle clicking comes from every piñon as I pass.
Unseen insects remarking on the heat, no doubt.
An unenthusiastic buzz from a listless rattlesnake
lays claim to a small patch of shade.
The quiet sound of water in the nearly empty streambed
reminds me of my own already diminishing supply.
Even the spirits are thirsty
and sunrise was just two hours ago.

"Burning Ruin", Southeast Utah

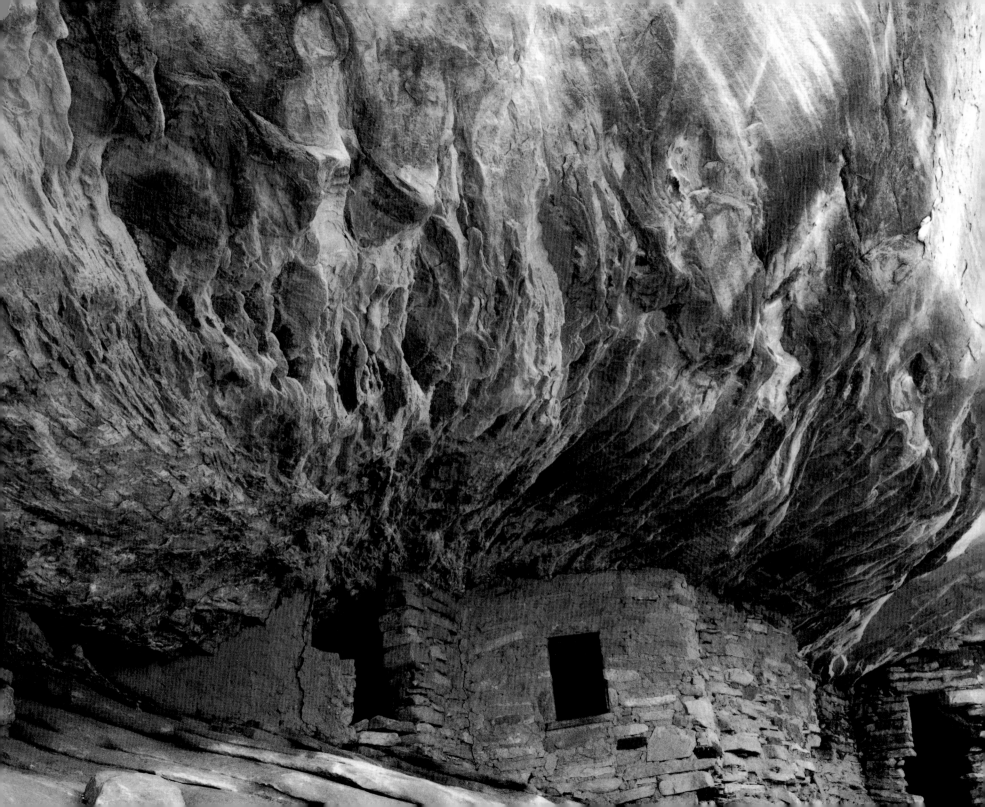

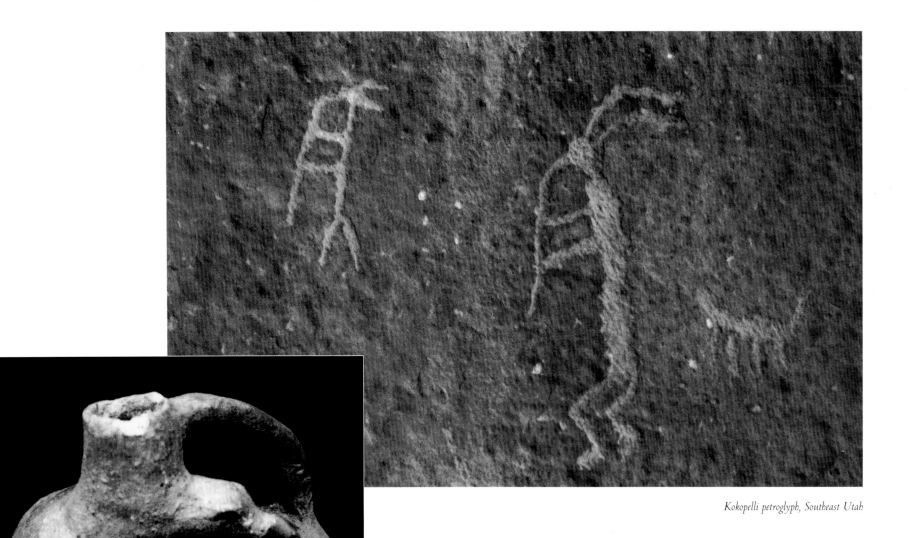

Kokopelli petroglyph, Southeast Utah

Chapin Gray effigy vessel, Edge of the Cedars State Park Museum

Anasazi Pueblos of the Ancient Southwest

Stephen H. Lekson

"Anasazi" is a word archaeologists use to describe the ancient settlements of the Pueblo Indians. Today, Pueblo people live in twenty small towns (or "pueblos") in New Mexico and another dozen villages on the Hopi mesas of Arizona. Eight centuries ago, they lived at Chaco Canyon and Mesa Verde, two of the most famous Anasazi national parks, and at tens of thousands of other sites that dot the "Four Corners" country—the high desert where New Mexico, Colorado, Utah, and Arizona meet. The Four Corners of the Anasazi covers over two hundred thousand square kilometers of sagebrush grasslands, redrock canyons and mesas, and pine-forested mountain ranges. Anasazi sites are found everywhere in this vast region.

When archaeologists first explored these magnificent ruins in the 1880s and 1890s, Pueblo people had long since moved to their current villages, far to the south. Navajo Indian people occupied the Four Corners, as they do today. Archaeological evidence suggests that Navajo people moved into the Four Corners centuries after Pueblo people left; but Navajo traditions state that they knew the residents of those ancient stone cities. The Navajo call them "ancient enemies" or Anasazi.

Navajo Hogan and pasture, Canyon de Chelly

the many clans that make up a Pueblo village has its own unique migration story.

Pueblo Indians would prefer that we use a Pueblo word, rather than the Navajo "Anasazi," to describe their ancestors. But the different Pueblo groups speak no less than four very distinct languages (Keresan, Tanoan, Zuni, and Hopi, and two or three more in prehistoric times). What word? Whose word? In compromise, many archaeologists now use "ancestral Pueblo" in place of "Anasazi"— which, of course, displeases many Navajo people.

Like its very name, much of what we thought we knew about Anasazi is in transition. New research and new ideas inspired by old excavations are changing our views of ancient life in the Southwest, and even the boundaries of that colorful region. "Anasazi" was originally applied to the ruins of the Four Corners; but if we equate it to "ancestral Pueblo," then the field must be expanded further south, well into Mexico. As we shall see, the great center of Paquimé, in Chihuahua, Mexico, is as important to Pueblo history as Mesa Verde or Chaco Canyon.

It is the Navajo word "Anasazi" that archaeologists borrowed for Chaco, Mesa Verde, and other ruined pueblos. The choice did not please modern Pueblo groups, whose oral histories tell another tale. Pueblo traditions recount long and complicated migrations: after emerging from an earlier existence beneath this present world, Pueblo people followed signs and instructions from spiritual guardians, wandering over much of the Southwest until they found their "middle place"—the locations of their present villages. Each Pueblo has its own middle place, and its own history; indeed, each of

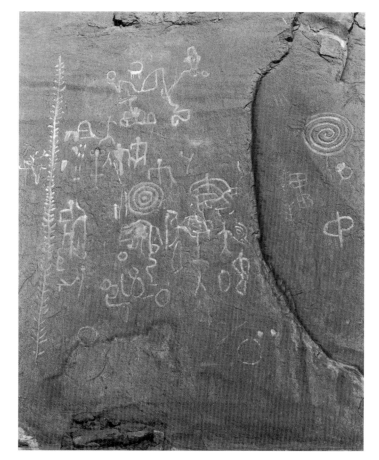

Yucca petroglyph panel,
Grand Gulch Archaeological Area

ORIGINS

Archaeologists and Pueblo people may never agree
on origins: archaeological data contrasts with Pueblo
traditions as much as Australopithecus contrasts
with the Garden of Eden. The spiritual mysteries of
Pueblo myth command our respect, and (as we shall
see) Pueblo migration stories are rich with historical
insights. And both archaeologists and Pueblo people
would agree that *corn* is essential to both prehistory
and traditional stories.

Corn was (and is) central to Pueblo life.
Together with beans and squash, it made settled
village life possible. Pueblo people did not have
farm animals, like cattle, pigs, and sheep; they had
dogs and turkeys, neither of which were major
sources of meat. The combination of corn, beans,
and squash—supplemented by deer or antelope or
other game animals, and a wide range of wild plant
foods—made a nutritionally complete diet. Only
when all these food elements were in place, was it
possible to build permanent towns, like the cliff
dwellings of Mesa Verde or the "great houses"
of Chaco Canyon.

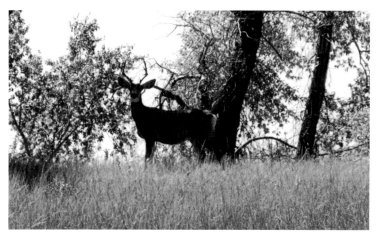

Mule Deer
(Odocoileus hemionus)

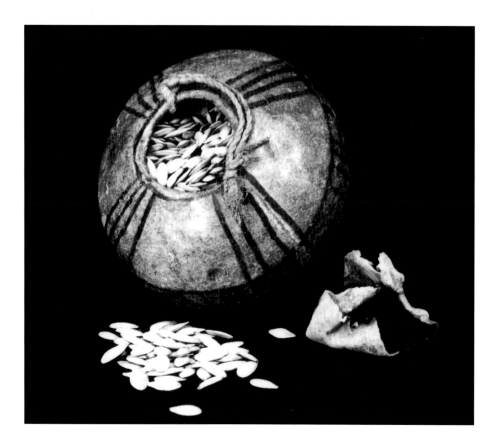

Piedra black-on-white seed jar filled with squash seeds (Cucurbita).
Edge of the Cedars State Park Museum

dig a room-sized pit; erect a timber framework inside that pit; then layer the excavated dirt over that frame to create a well-insulated roof, and that is a pit house.

Pit houses were the traditional home in the agricultural villages of southern Arizona and New Mexico for over two millennia, from 1000 B.C. until A.D. 1000. They were the traditional house form for the Four Corners Anasazi villages for a much shorter span, from about A.D. 500 to 1300. The Pueblo people—famous today for towering, apartment-like villages—lived for eight centuries in pit houses.

Shortly after corn, pottery appears. The first pottery was plain brown (the color of the clay), not the brilliantly painted bowls and jars we associate with later Pueblo ceramics. Throughout the Southwest, in the Pueblo world and beyond, the earliest pottery was remarkably similar: nicely formed brown pottery, occasionally with a thin coating of red clay, polished to a low gloss. This uniform pottery suggests that there was a "base" culture—a bedrock of pit house farming villages with brown pottery—from which the various Southwestern traditions (including the Pueblos) differentiated and developed. Archaeology hints at common origins; language diversity and traditional tribal histories argue otherwise.

It took a while. Corn was originally domesticated far to the south, in Mexico. We now know that corn reached the Southwest and the Four Corners region about 1000 B.C. At first, it made little difference to the older hunting and gathering lifestyle. The first Anasazi villages were built in the Four Corners area about A.D. 500, long after corn arrived. During the millennium-and-a-half when Anasazi people were experimenting with corn, sizable settlements rose and fell in the deserts of southern Arizona, southern New Mexico, and northern Mexico. Those desert villages were not pueblos, but rather "pit houses"—

MIGRATIONS

Pit houses are simple to build; that is one of their principal attractions. The sod homes of our nineteenth-century prairie pioneers were pit houses, used only for the year or two it took to build a frame or masonry farmhouse. Ancient Southwestern pit houses were also intended to last only a short time, perhaps less than a generation. In a decade or so, roof support timbers would rot and the bare dirt walls would collapse. The first big Anasazi villages, about A.D. 500, appear today as dozens of pit house remnants—shallow circular swales or depressions left after a house collapsed, and its pit was filled with blowing sand. Shabik'eschee, one of the largest excavated early pit house villages, has over fifty pit house depressions. Fifty houses seem like a big village, but research shows that only a few of the houses were used at any one time, and then only for part of each year. Pit houses were used and then fell into disrepair; new houses were built rather than rebuilding the old houses. The "village" itself was a place visited and revisited only when local plant foods were ripe and available. Shabik'eschee—one of the largest early pit house villages—was never home to more than a few families at one time.

Sosi black-on-white ladle bowl,
Edge of the Cedars State Park Museum

Early Anasazi households moved around. During different times of the year, they would move to be nearer the different economic tasks at hand. At planting and harvesting, they lived near their cornfields; at other times, they relocated closer to ripening wild plants or other resources. There were no wagons or pack animals to move food to the village, so families moved to the food. That was the annual cycle; but a longer, larger cycle of movement also occurred. After a couple of decades in one area, firewood was cut, game was hunted out, and farm fields were depleted. An entire community might move into a new area with richer resources. Generation after generation, villages shifted from valley to valley, perhaps eventually reoccupying and rebuilding on the sites of their great-grandparents' homes, after nature had restored trees, game, and soil.

Movement on that scale—entire villages moving over large distances—is recalled in Pueblo migration stories. For the earliest time periods, migration stories seem figurative and metaphorical—like Greek myths—recalling the generalities if not precise events. In later periods, Pueblo stories are quite specific about exact villages and their sequence of use, abandonment, and movement; we will return to those accounts, later. From A.D. 500 to 900, Anasazi villages moved back and forth across the Four Corners region. There are many sites, but because of the pattern of movement, those sites do not represent very many people. Despite the ambiguities of many sites equaling few people, archaeologists have tried to estimate the total population in the Anasazi Region. By about A.D. 900, there were about forty thousand people in small villages scattered over this vast area.

We know in some detail the archaeological history of those early towns. As corn became more and more important, and empty valleys began to fill with new peoples, the villages became more permanent. They grew larger and larger, eventually including dozens of families, but you will not see many of those early villages in the national parks, because—as archaeological sites, today—their pit house swales are not very visible. (Mesa Verde is the best place to see excavated early Pueblo villages.)

The potters' craft evolved as villages became more permanent. Each village, and perhaps each family, made its own pottery. With better clays and firing conditions, brown pottery was replaced by harder gray pottery. A thin coat of fine white clay was often applied to the inside of bowls and the outside of jars, and designs painted in black on that white background. The tradition of Anasazi black-on-white pottery decoration began about A.D. 500 and lasted in some parts of the Pueblo world after A.D. 1400. It continues today at Acoma and a few other Pueblos.

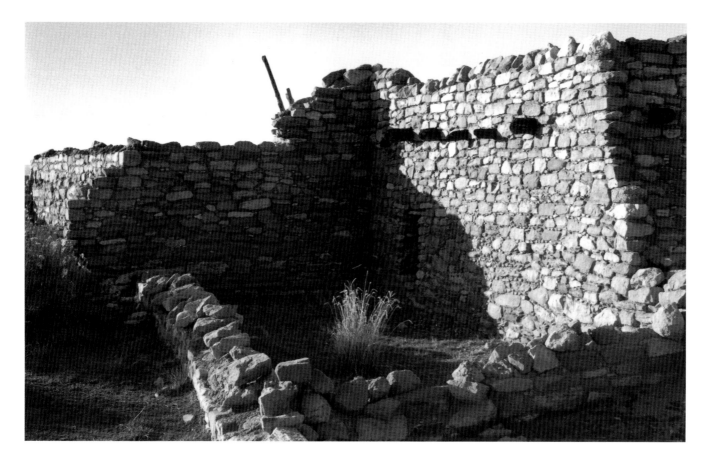

Early pueblos were not built of the finely crafted sandstone masonry of Chaco and Mesa Verde. Rather, early villages were increasingly elaborate masonry-lined pit houses, each with a set or suite of nearby aboveground rooms. Those rooms built of rough slab masonry and puddled mud ("adobe") were built for the storage of corn and for specialized tasks, like grinding cornmeal (a daily task for each family) and cooking. The aboveground rooms ("pueblos") eventually became the Pueblos we see today at Taos and Zuni, but they began as granaries and kitchens and workshops. From A.D. 500 through 1300, the real home remained the pit house.

By about A.D. 850, there were dozens of very large pit house villages in the Four Corners area. Then a prolonged drought made farming very difficult, and most villages migrated south seeking wetter weather. This was the first "abandonment" of the Four Corners, as complete and dramatic as the later, more famous "abandonment" of Mesa Verde at A.D. 1270 (to which we will return).

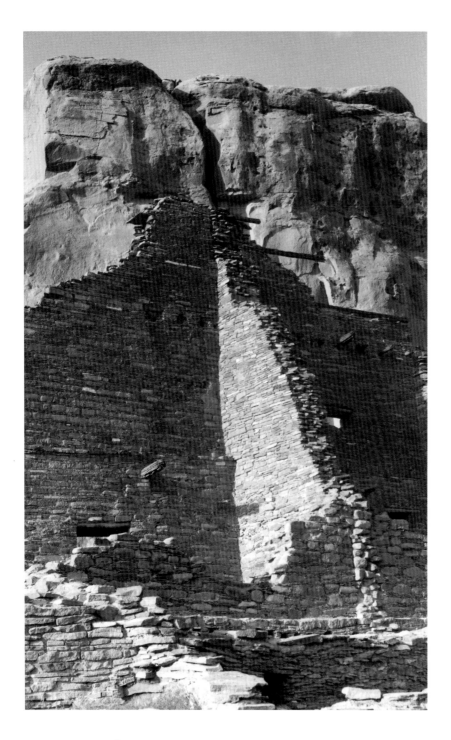

REGIONAL SYSTEMS

Frequent village movements were combined and condensed in dozens of Pueblo migration stories, which often convey more cultural teaching and wisdom than precise historical details. Many of those stories converge, however, on a specific historical episode at a real historical place, called "White House."

"White House" probably refers, at least in part, to Chaco Canyon, the first great regional center in the Pueblo world. Chaco, which flourished from A.D. 900 to about 1125, was a ceremonial city on a scale unprecedented in the Southwest. Huge sandstone masonry buildings, which archaeologists call "great houses," rose five stories tall, encompassing hundreds of rooms in ground plans of semi-circles, ovals, and rectangles covering areas larger than football fields. Great houses were planned and constructed with remarkable organization of labor and materials. Tons of shaped stone and mud mortar had to be prepared for each meter of wall. Over two hundred thousand pine beams were cut in mountain forests far from Chaco and transported, without wheels or beasts of burden, up to sixty kilometers across the desert. (We can determine the exact date when those trees were cut

from tree rings, the annual growth rings evident in the cross section of tree stumps.) Rooms inside the buildings were large and tall. At the average Pueblo house of that time, a room was about 1.5 meters by 2 meters with a ceiling well under 2 meters tall. Great house rooms were three or four times that size, and their ceilings were up to 4 meters tall. The rooms were arranged in precise lines, with doorways aligned from front to back. But the exteriors of great houses were even more impressive: Great houses were designed with rigid, formal rules and set proportions, and they were meant to be seen and to impress the viewer. Chaco was planned on a meridian grid; true north and other celestial directions were built into individual buildings and into the city plan.

In its context, Chaco was a true city, but it never had more than twenty-five hundred to five thousand inhabitants. Contemporary cities in ancient Mexico had ten times that many people. Over the entire Anasazi region, the population reached about one hundred thousand people; the population would stay at about that level for the next four or five centuries although, as we shall see, those people continued to move and migrate.

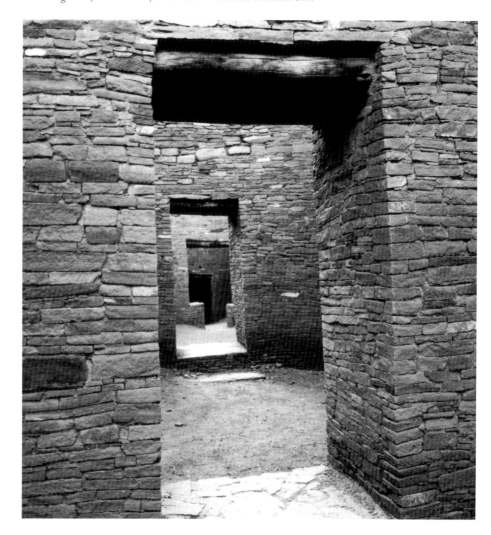

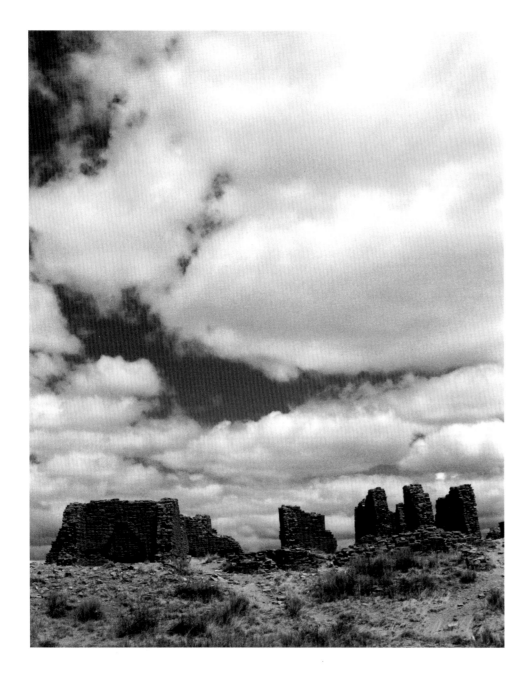

Archaeologists think that Chaco arose in its arid, inhospitable canyon as a "central place," storing and distributing corn and other materials to surrounding settlements in the San Juan Basin, a 120 kilometer in diameter desert in northwestern New Mexico. Chaco may have begun as an economic node but it soon graduated into the political and ceremonial capital of a much larger region, incorporating most of the Pueblo world by A.D. 1100. "Roads"—six meter wide, cleared pathways that ran straight for many kilometers—radiated out to "outliers," or small great houses built to Chaco plans with Chaco-style masonry, over two hundred kilometers away from Chaco Canyon. Over 150 "outlier" great houses have been found; many are interconnected by "roads" like those emanating from Chaco Canyon.

Recall that Pueblo people had no carts or pack animals. Over those vast distances, without transport, it was not practical to ship bulk produce like corn, as had been the case inside the smaller San Juan Basin. Chaco's role in the much larger regional system was marked by its monopoly on more portable precious items such as turquoise (from mines near Santa Fe, New Mexico), and copper bells and bright parrot feathers (from western Mexico, one thousand kilometers to the south).

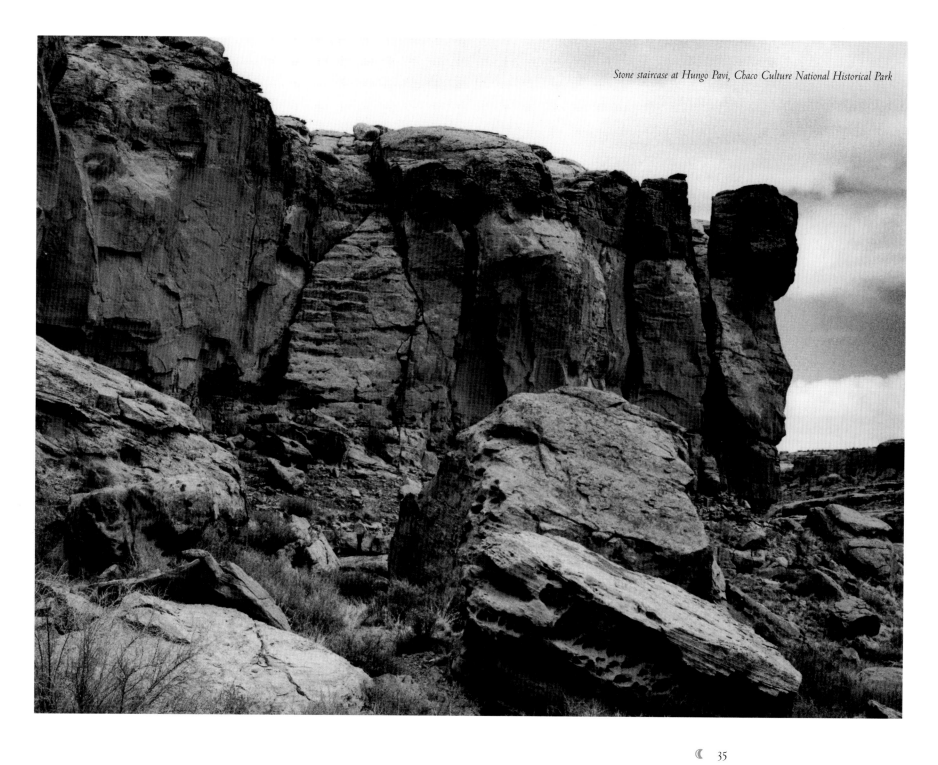

Stone staircase at Hungo Pavi, Chaco Culture National Historical Park

Chaco, or White House, became the Anasazi capital—if not a political capital like Washington or London, then a spiritual center like the Vatican City or Mecca. The U.S. Constitution separates church and state, but that was never the case in Pueblo life. In many Pueblo migration stories, White House is remembered as a marvelous place, where the people enjoyed economic and spiritual prosperity. But, after many years, bad things happened—individuals behaved in ways inappropriate for Pueblo people today, who value community welfare and group identity over personal advancement. Zuni Pueblo people remember a form of government, lost in the distant past, in which a small group of leaders lived in a great house. Those elite leaders—"masters of the great house"—did not grow corn or hunt or work; their needs were supplied through a form of taxation. Great house government was anomalous in Zuni memory and no Pueblo is ruled that way today. Indeed, many intertwined aspects of Pueblo society prevent any individual from acquiring that kind of political power.

At Pueblo Bonito, the most important Chaco great house, excavations revealed the elaborate tombs of two middle-aged men, interred with great pomp and many rare objects. These are the two most impressive "high status" burials in Pueblo prehistory, and they may represent the behavior that brought White House to an end.

RED HILL AND THUNDERSTORMS

An old Southwestern adage says: "the sky determines."
In this arid land, rainfall is critical. There is barely
enough rain for corn farming, and the most
important precipitation comes from late summer
storms. Spectacular lightning crackles beneath a
towering white thunderhead, torrential rain pelts
a few acres of the desert, and then the storm
blows through, bringing its life-giving water to
the next valley. Pueblo people see kachina spirits
in those clouds. Their prayers, kachina dances,
and ceremonies ask for the return of the clouds,
and a good harvest.

We can reconstruct, in great detail, the history
of rainfall in the Southwest. The relative widths (and
other characteristics) of the annual growth rings of
ancient trees allow scientists at the Laboratory of
Tree-Ring Research at the University of Arizona to
project the actual amounts of rain in each season
of each year. We can "see" the droughts: a serious
decade-long drought about the time construction
ceased at Chaco Canyon, and then the Great
Drought—twenty-five years of little rain from about
1275 to 1300—precipitated the abandonment of the
Four Corners. But as important as the *amount* of
rainfall was its *patterning*: in Pueblos, enough corn
is stored to feed the village for two years, because
small two-year droughts are typical. Too many three-
and four-year droughts, however, were disastrous.

Afternoon storm clouds, Mesa Verde National Park

The Great Drought, from about A.D. 1275 to 1300,
has become legendary in archaeology. It coincided
with the the final and complete abandonment of
the Four Corners region. But we now know that
Pueblo Indians of the Four Corners had survived
similar droughts, centuries before. Recent analyses
show that the Great Drought was not just dry, it
was wildly unpredictable. After A.D. 1250, familiar
patterns of rainfall become chaotic, exacerbating
the larger problem of low rainfall.

Nevertheless, complex computer models of rain, soil, and crop production show that, even during the height of the Great Drought, the Four Corners could have supported large farming villages. There was no reason for *everyone* to leave; yet they did. The sky determines, and much of Pueblo prehistory can be understood scientifically as responses to rain and drought. But Pueblo leaders also made decisions, based on prayer and policy that encompassed more than just rainfall and crop production.

Spiritual insights, economic opportunities, political alliances, and spectacular events in nature undoubtedly influenced decisions and directions. Pueblo leaders made rational decisions based on carefully considered facts; but Pueblo religion was very closely connected to the land and to nature, and natural events were taken very seriously. Sometime in the early 1100s (at the height of Chaco Canyon) a phenomenon unique in Pueblo history occurred: Sunset Crater (near Flagstaff, Arizona) erupted. The Hopi call this small volcano "Red Hill," and remember it in their oral histories. There had been no volcanic eruptions in the Southwest for three hundred generations. Some Pueblo travelers had probably seen smoking mountains in Mexico, but for the vast majority of Southwestern people,

Red Hill was an unprecedented wonder. A towering, violent plume shot up from the crater. It was visible from Chaco Canyon, and most of the Southwest. Lightning flashed day and night through the ash-laden clouds; the thunder was drowned out by the rumble of volcanic explosions. Red Hill became a huge, permanent thunderhead. Lava flows and smaller eruptions continued for decades.

It is probably no coincidence that when large-scale construction was ending at Chaco Canyon, one of the last, most distant Chacoan "outliers" was built near the base of Red Hill. Wupatki (constructed between A.D. 1135 and 1195) combined the ceremonial architecture of Chaco Canyon with the remarkable "ball courts" of the southern Arizona desert, symbols of the rival Hohokam regional system. They hedged their bets, combining old Chacoan ideologies with ceremonies borrowed from distant societies.

For over a century, Chaco had been the peg on which the Pueblo world turned. When Chaco ended about A.D. 1125, the power of Red Hill offered a new world axis. Wupatki was, however, a distant place, far from the dense population centers of the Four Corners. A more immediate solution was needed, to replace Chaco and restore order.

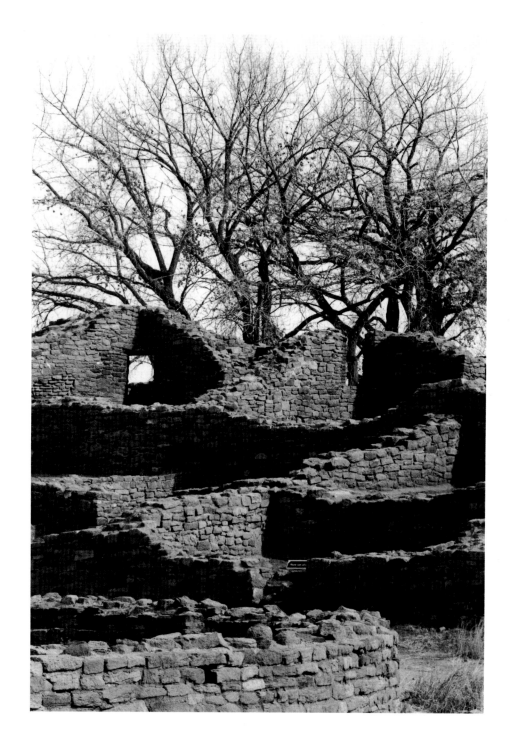

CHACO AND AZTEC RUINS

Eighty kilometers due north of Chaco Canyon
lies Aztec Ruins—named, mistakenly, by early
White settlers who thought the site might be
the mythical homeland of the Aztecs of central
Mexico. The settlers were wrong; but Aztec
Ruins was an extremely important place.

Construction of Chaco Canyon great houses
ended about A.D. 1125. Building on that same
monumental scale, with the rigid formal
symmetries and proportions of Chaco, began
at Aztec Ruins a few years earlier (about A.D. 1100)
and continued, unabated, until about A.D. 1270.
When Chaco ended, Aztec began.

New discoveries suggest that Aztec Ruins was,
in effect, the "new Chaco." Visitors to Aztec Ruins
see a single large and impressive building, excavated
in the 1920s, very much like the great houses of
Chaco Canyon. Recent mapping of other unexcavated
buildings show that Aztec was a ceremonial city
comparable to Chaco. Hundreds of new tree
ring dates, taken from the roof beams of these
unexcavated buildings, show that monumental
building continued at Aztec from 1110 until 1270.

Corn grinding room, Aztec Ruins National Monument

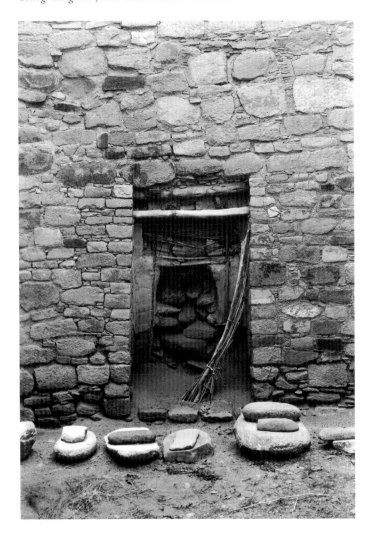

Aztec was linked to Chaco by the most impressive of all the Chaco "roads," called the North Road because it runs due north out of Chaco to Aztec Ruins. The final few kilometers of the North Road are obscured by erosion, but many archaeologists believe that the North Road connected the two centers. This is curious, because Chaco and Aztec were not contemporary: Chaco dates from A.D. 900 to 1125, and Aztec dates from A.D. 1100 to 1270. The North Road was a "road through time"— in the words of the archaeologists who first recognized that Chaco "roads" were not highways, but landscape monuments. "Roads" were used to commemorate the connections between politically related settlements: first, Chaco and its outliers, and then Chaco and its successor, Aztec.

Aztec was a smaller version of Chaco, and may have continued its role as White House. Aztec Ruin's regional center probably incorporated Mesa Verde and the huge thirteenth-century towns of southwestern Colorado and southeast Utah, reestablished after the earlier A.D. 900 abandonment. Mesa Verde—the most famous archaeological site in the United States—was simply one of many farming communities in the Aztec regional system.

The towns of Mesa Verde, however, are by far the best preserved of the Anasazi sites. They were built within huge alcove-caves, and the overhang of the sandstone cliffs sheltered them from rain and snow. That was useful in the thirteenth century; rain and snow would soak through the flat

40 ☾

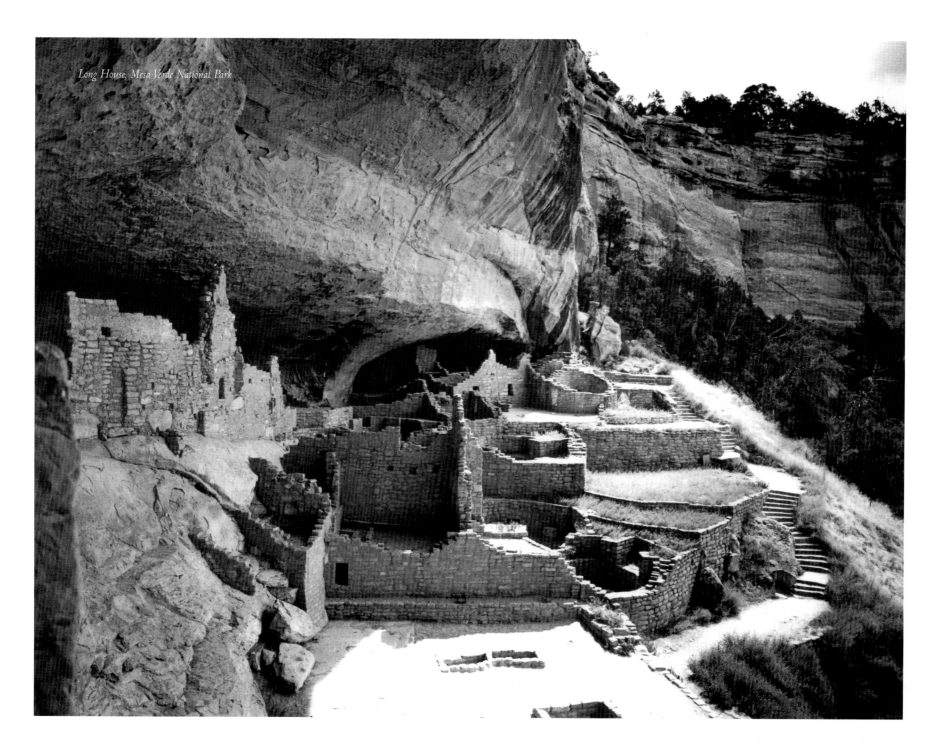

Long House, Mesa Verde National Park

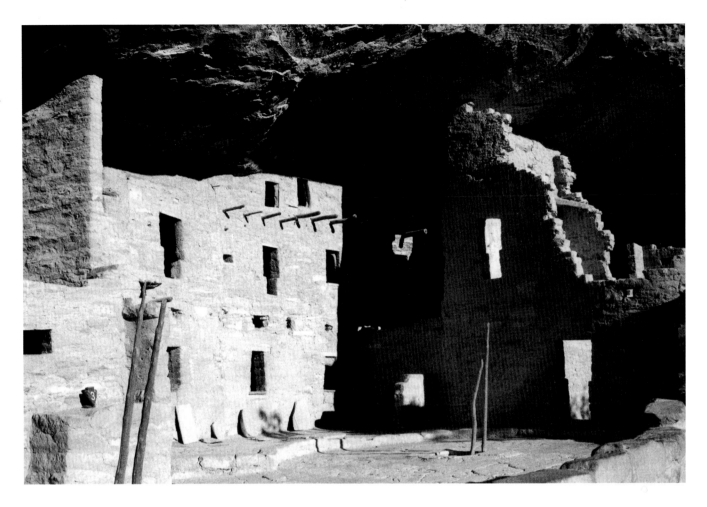

Spruce Tree House, Mesa Verde National Park

earth-covered roofs and seep into mud-mortared walls, requiring almost constant maintenance at most villages. "Cliff-dwellings" avoided those problems. The overhangs protected the villages long after their people left: seven centuries later, Mesa Verde sites like Cliff Palace and Spruce Tree house look almost exactly as they did in A.D. 1300. We can see how their builders tucked rooms and towers into corners and alcoves of the caves, and terraced buildings up the cave's rear slopes. The villages look like they were stacked up at random, like a child's building blocks but, at the same time, they fit perfectly into their place.

Large-scale building ends about 1270 at Aztec, and about that time the Four Corners is abandoned, totally and finally. A severe drought began about 1275, but the region could have supported a substantial population. There was no reason for everyone to leave, but everyone did leave—tens of thousands of people moving south to find new homes, new middle places.

Warfare

The thirteenth and fourteenth centuries, all over the
Pueblo world, were marked by violence. Raiding, warfare,
and even cannibalism appear. Most archaeologists agree
that this period was the bloodiest in Pueblo history.
The preceding Chaco era, in the eleventh and twelfth
centuries, was relatively peaceful, controlled by the
strong central power at Chaco Canyon. Carefully
measured military violence may have been employed
by Chaco to impress peace on the regional system.
But Aztec, the "new Chaco," could not keep the
peace. Village attacked village and things fell apart.
The cliff dwellings of Mesa Verde were wonderful
building sites, but most importantly, they were safe
and highly defensible.

The abandonment of the Four Corners, between
1250 and 1300, reflected the disruption. Tens of thousands
of people moved south, joining already substantial
populations at Hopi, Zuni, Acoma, and along the
Rio Grande. So explosive were the migrations out
of the Four Corners that some groups spilled off the
vast high deserts, down into the low deserts of southern
Arizona and southern New Mexico. Sites identical
to those in northeastern Arizona have recently been
excavated just east of Tucson, Arizona; large ruins with
Mesa Verde–style pottery have been found within one
hundred kilometers of El Paso, Texas. And even further
south, the third and final great Pueblo center rose near
Casas Grandes, in Chihuahua, Mexico. This site, called
Paquimé, continued the role of Chaco and Aztec, in a
highly modified form. We will return to Paquimé, below.

Eagle's Nest, Southeast Utah

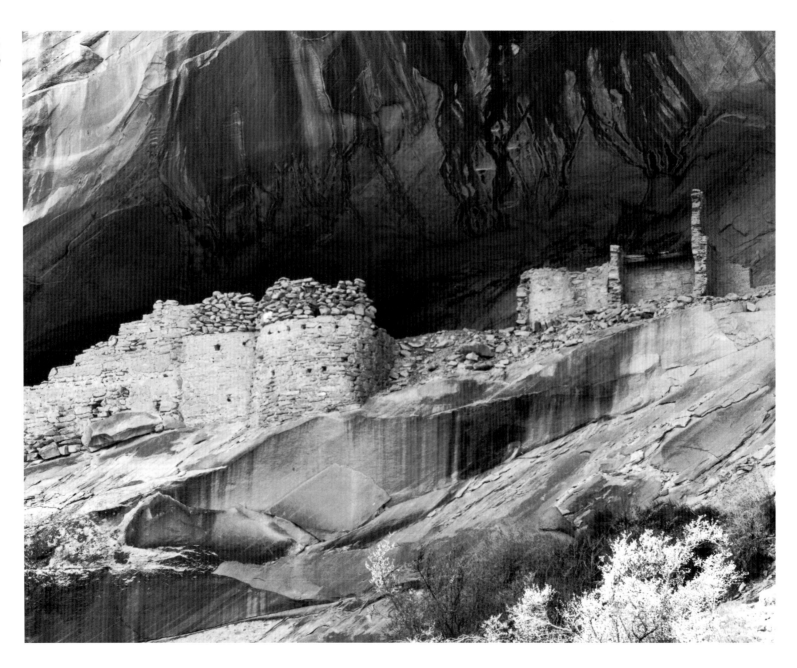

Monarch's Cave,
Southeast Utah

44 ☾

Coyote pitcher, Edge of the Cedars State Park Museum

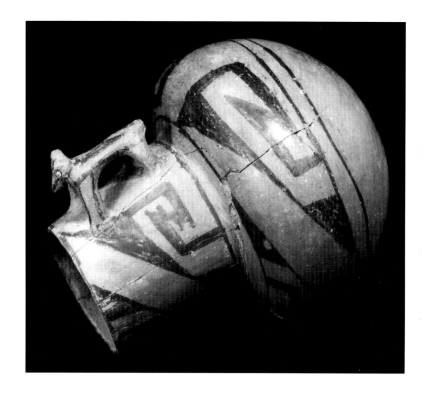

In the northern Pueblo world, pueblos increased rapidly in size. Many, like the cliff dwellings, appear planned for defense. Big villages closed in around springs and other water sources, presenting unbroken outer walls to an increasingly violent world. Pueblo Bonito, largest of the Chaco great houses, had six hundred rooms; the largest villages immediately after Aztec's fall (near Zuni) had fourteen hundred rooms. Whole regions were structured by defense: in the Kayenta region (north of Hopi), archaeologists have established that village locations, atop defensive knolls and buttes, were fixed and determined by inter-visibility with other villages. People were nervous.

The intrusion of thousands of new people, looking for land, could have resulted in even greater chaos. In some cases, new people were briefly tolerated and then attacked, driven out, or killed. At Point-of-Pines, a huge community at the southern edge of the Pueblo world, an enclave from the Kayenta area was served just that way, their houses burned and razed. But in most places, new peoples were incorporated through the development of new ceremonial systems that could integrate new clans and villages into existing communities.

The mixture of so many different people with different traditions sparked important changes in pottery and art. The old black-on-white styles of the Four Corners gave way, after A.D. 1300, to a range of more colorful pottery: black and white designs on a red background, red and black on a yellow-tan background and, in the Rio Grande valley, new pottery paints that "glazed," turning shiny and metallic when the pottery was fired. A new art form—wall murals—showed the development of remarkable new ceremonies and rituals: the kachinas.

Macaw feather sash, Edge of the Cedars State Park Museum and Kent Frost

KACHINAS AND CURING SOCIETIES

Kachinas—elaborately masked and costumed dancers who embody spirit beings—are the most public and best-known aspect of Pueblo religious life. Kachina "dolls" made at Hopi and Zuni grace art collections from San Francisco to New York City. The Pueblos pray and celebrate through Kachina ceremonies in which masked dancers communicate directly with the spirit world.

Archaeologists have long wondered about the origins of this dramatic, powerful Pueblo ritual. Pueblo people know that the real kachinas—spirit beings—were always here. At White House, the spirit beings actually lived with the people, until they were driven away by the improper behavior that ultimately ended that great city. Before they left, the spirit beings taught Pueblo people the rituals and ceremonies that we see today as kachina dances. Thus, the beginnings of kachina ceremonialism are linked to the fall of White House—Chaco, Aztec, or both.

Archaeologists take a different, but not necessarily contradictory, view. We can only work with images: pictures pecked into cliffs, painted on pottery, carved in wood, or painted on wall murals. And we often don't know exactly what those images mean. We can only judge how similar they are to modern kachina masks and costumes.

The earliest images that archaeologists identify as kachinas appear far to the south of Chaco in the Mimbres area of southwestern New Mexico.

Along the Mimbres River, a vibrant society contemporary with Chaco produced remarkable images on pottery, rock art, and sculpted figurines that look like early versions of modern kachinas. Mimbres was the southernmost district of the Pueblo world during the Chaco era, and many threads of kachina ceremonialism originated even farther south, in Mexico (much like corn, millennia before). Mimbres villages, from about A.D. 1000 to 1125, were loosely integrated into the Chacoan regional system, but kachina images never appear at Chaco Canyon (or at Aztec Ruins, after Chaco).

With the fall of Chaco, about A.D. 1125, the trail of kachina symbolism shifts to central Arizona and Red Hill. Archaeologists are beginning to unravel a complex history that places the crystallization of kachina imagery at Wupatki, where Mimbres ideas were transformed beneath the plume of the eruption, by the remarkable amalgam of Chaco and Hohokam ceremonialism. As with the interpretation of Mimbres art, there is much debate over this hypothesis.

The first unquestionable expressions of kachina images in rock art and pottery appear shortly after Wupatki, nearby on the Little Colorado River in central Arizona. Archaeologists investigating the ancestral Hopi towns have shown that kachina symbolism, as it appears today, originated in the towns in the Little Colorado headwaters, as they were impacted by the arrival of thousands of Pueblo people leaving the Four Corners. In some towns,

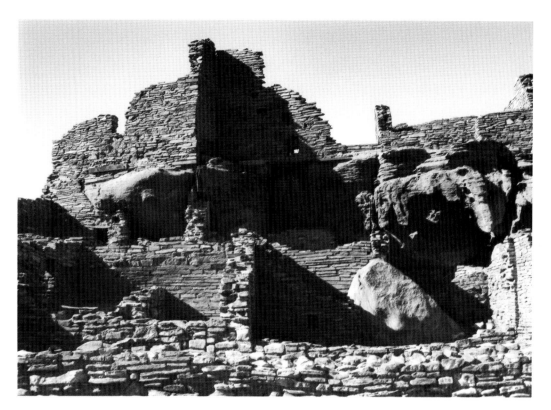

Wupatki Ruin, Wupatki National Monument

as noted above, massive immigration led to violence. But in most Pueblo towns, new and newly elaborated ceremonials allowed incoming people to be incorporated peacefully into the community.

In the Rio Grande valley, other spiritual institutions seem to have been even more important than kachina ceremonies. Many thousands of Four Corners people moved to the Rio Grande, where total population rose dramatically after 1275. Inevitably, some violence and even warfare resulted; but religious organizations worked hard to incorporate newcomers.

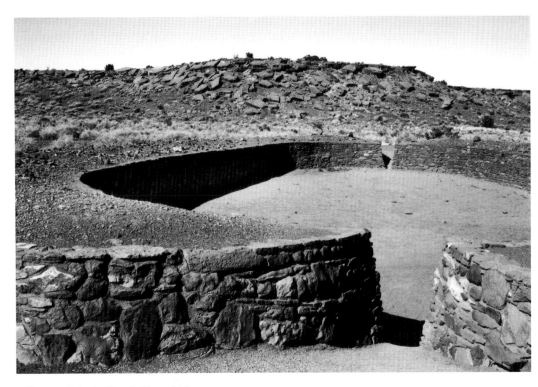

Ball court at Wupatki, Wupatki National Monument

Many archaeologists think that "curing societies"—ceremonial organizations that healed both individuals and communities—were the Rio Grande's response to the stresses of the thirteenth and fourteenth centuries.

All over the Southwest after 1300, there was an explosion of ideologically charged art and images, responses to the massive population movements out of the Four Corners area. Kachinas and curing societies continue in Pueblo villages today. Other widespread religious or ceremonial movements have been defined by archaeologists, but they may not survive today in recognizable form. Certain pottery styles (most importantly, a distinctive

black-white-and-red type called "Gila Polychrome") apparently signaled a settlement's participation in a short-lived, but widespread "Southwestern Cult"; other brief regional religious movements have been suggested by archaeologists. The fourteenth and fifteenth centuries were a time of religious ferment and experiment.

Religion and ceremony brought Pueblo peoples through those difficult tumultuous times. Many of those traditions continue today, unbroken, in towns at Hopi, Zuni, Acoma, and along the Rio Grande. The Pueblo people survived *as villages*, sharing a worldview but independent in economy and politics. The regional systems of Chaco and Aztec did not continue in the northern Southwest. However, there was a third regional system. That final political center was Paquimé—the most spectacular and most mysterious of the ancient Pueblo capitals.

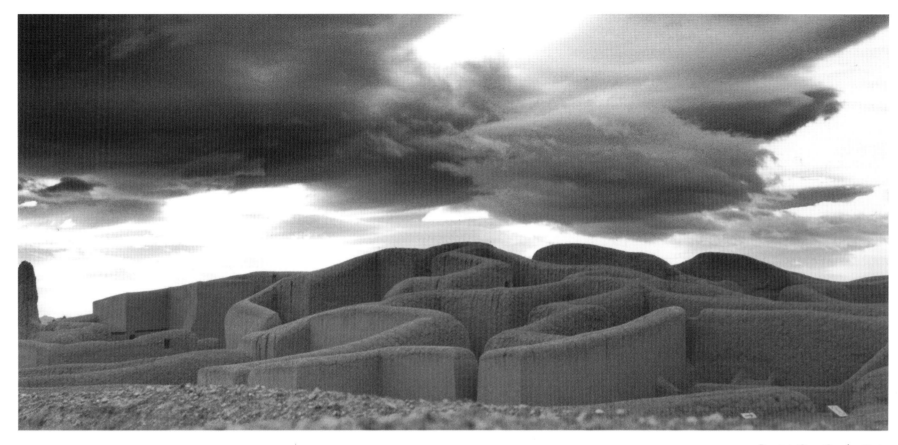

Paquimé, Casas Grandes, Mexico

Paquimé

Paquimé was a great city, built between A.D. 1250 and 1400. Its ruins lie just outside the modern city of Casas Grandes, 150 kilometers south of the international border in Chihuahua, Mexico. While Chaco Canyon and Mesa Verde have been investigated for over a century by scores of archaeologists, Paquimé is known only through one major research project, a joint undertaking of the Amerind Foundation in Arizona and Mexico's Instituto Nacional de Antropología e Historia in the 1960s. Recently, several large projects are investigating this important, but little known region. At Paquimé itself, about one-third of the city was excavated, and it contained wonderful things.

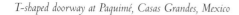

Paquimé itself was a huge, pueblo-style settlement built of thick poured-adobe walls. During the fourteenth and fifteenth centuries, it was the largest and most impressive Pueblo site in the Southwest. Its ceremonial precincts, outside the city proper, combined Mesoamerican ball courts (small versions of those at Tula and Chichen Itza) and platform mounds (small versions of central Mexican pyramids) with Pueblo great kivas. Colonnades—another central Mexican architectural form—graced the plaza-facing walls of many Paquimé public buildings.

Running water was channeled through Paquimé from a large spring, 3.5 kilometers distant. Thousands of finely finished pine beams were brought forty kilometers from forests high in the Sierra Madres. The scale of planning and the organization of construction labor recall Chaco Canyon; Paquimé may have been the last expression of the political system that began at Chaco.

Within the buildings of Paquimé, archaeologists found impressive evidence for wealth, trade, and craft specialization. One warehouse contained over one thousand kilograms of Pacific Ocean shell. Astonishing quantities of copper bells and other items were imported from western Mexico. Chaco, Wupatki, and Aztec had imported the brightly plumed macaws. Paquimé actually bred the birds. Over five hundred macaws and parrots were found, many inside the box-like breeding pens that lined several plazas. Other products were commercially produced such as large-scale turkey farming and

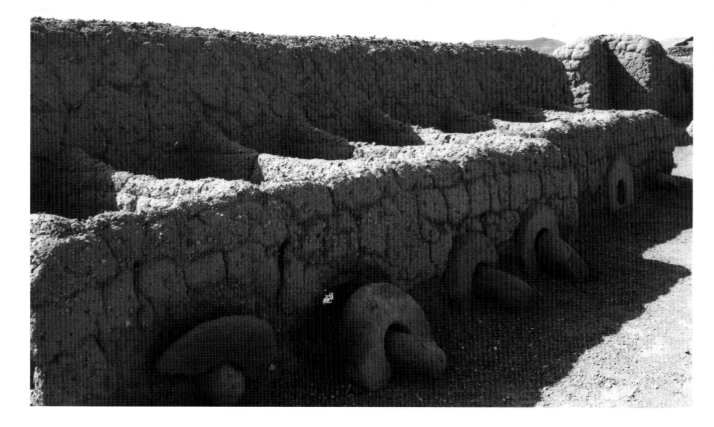

*Macaw pens at Paquimé,
Casas Grandes, Mexico*

agave production (agave is an important food plant, native to the foothills of the Sierra Madres). Paquimé was not simply "another Pueblo"; it was a commercial, political, and ceremonial center of the first order.

Archaeologists and Pueblo people are just beginning to understand Paquimé, and its place in Pueblo history. Several Pueblo histories recall an event during their departure from White House. When the people left White House, they were told to travel straight south. Many stopped at places like Acoma and Zuni; but some continued on, straight south, seeking a place to raise macaws. The Pueblo histories do not say where that group finally settled, but some returned as traders, with macaw feathers and shell jewelry. Paquimé may well be the southern city, heir to White House.

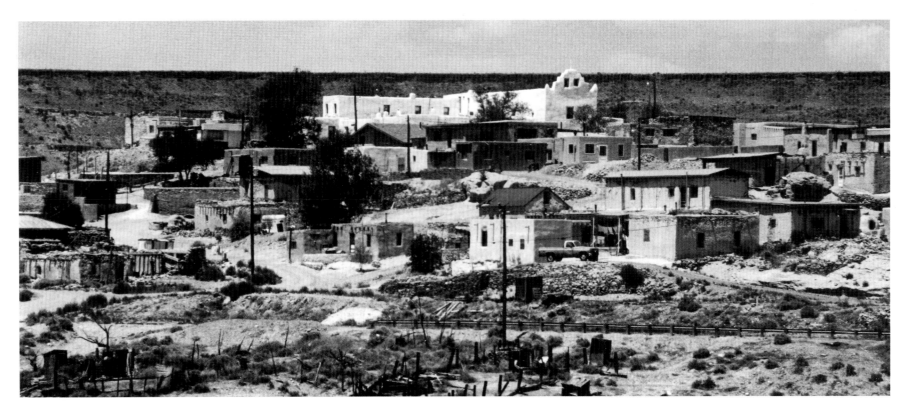

Laguna Pueblo, New Mexico

New Directions

A century after Europeans reached the New World, conquistadors invaded the Southwest. The United States took the region from Mexico about A.D. 1850, and brought different disruptions. Pueblos, Navajos, and other Southwestern peoples endured centuries of Old World colonization, germs, and religions. The clash of cultures was disastrous. Core values and beliefs survived, but native populations were decimated by terrible epidemics of European diseases. From a peak population of about one hundred thousand, Pueblo villages plummeted to less than fifteen thousand by the year 1700.

Today, those native groups have rebounded; they are strong, vital, growing societies. But many of the old political and social institutions are gone, suppressed by church and state, or toppled by economic catastrophe. Nothing like Chaco, Aztec, or Paquimé exists today in the Pueblos, except as memories and histories.

Archaeologists can reconstruct the Southwestern past, and in collaboration with Native peoples, the rich history of the region is emerging as a compelling episode in human history, a valued part the world heritage.

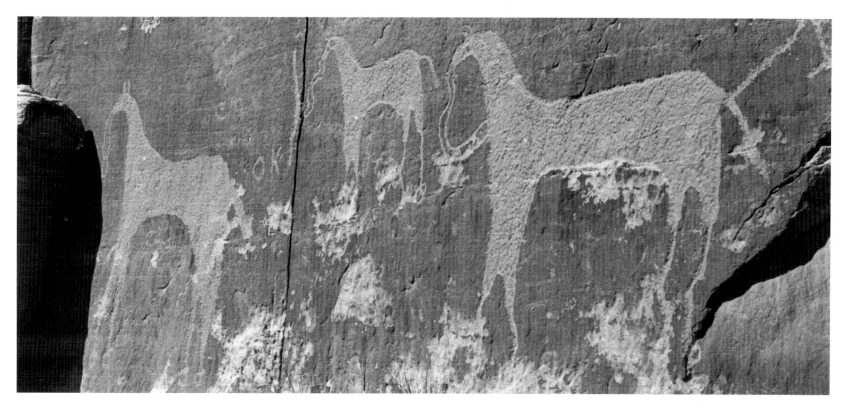

Navajo horse petroglyphs, near Bluff, Utah

And that's a problem. Non-Indian people (like the author and most readers of this essay) are intrigued by the Pueblo and Southwestern past, but it is not *our* past. The remarkable success of places like Crow Canyon Archaeological Center, where anyone with a real interest in the Southwestern past can participate in Southwestern archaeology, testifies to a broad, enduring interest in Native America and its past.

But Native America has a present and a very strong future; and Pueblo and Navajo communities (among others) are ambivalent about *White* interest in their past. Several Pueblos and the Navajo Nation have formed their own archaeological and cultural preservation programs, undertaking archaeology for the benefit of their tribes and regaining control of their past. New laws and new attitudes are moving control of the Native American history from universities and museums back to the tribes themselves. A new era of Anasazi archaeology is emerging, but it is too soon to tell what the future holds for the past.

Grand Gulch and the San Juan River

Photographs and Reflections
John L. Ninnemann

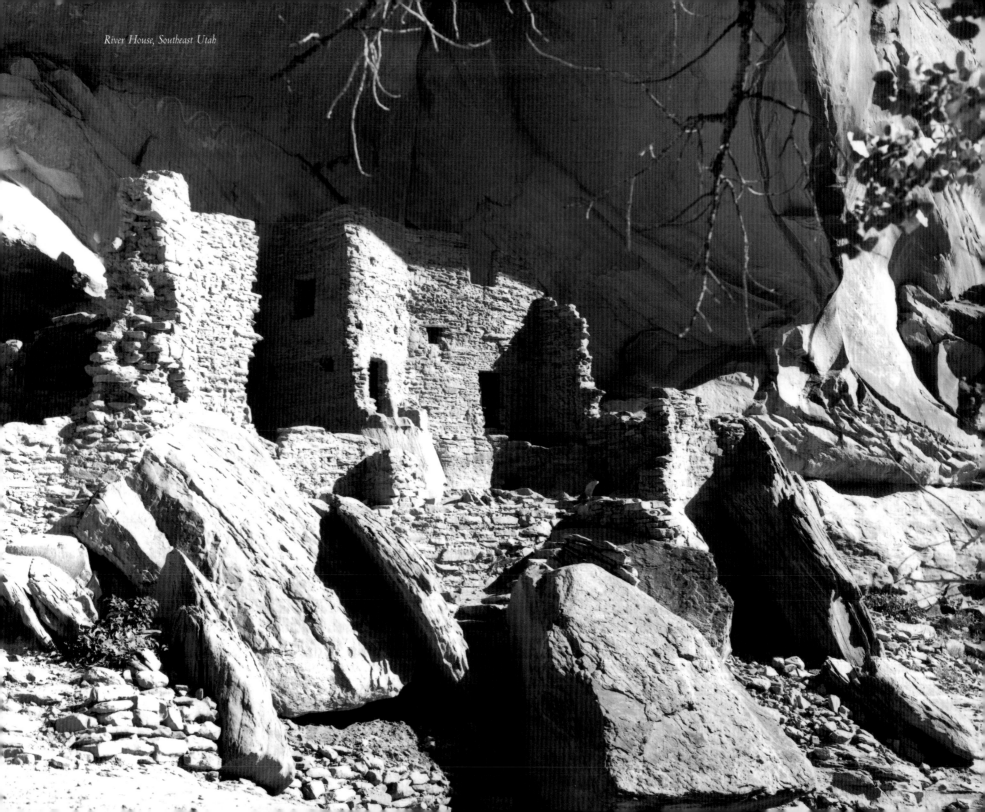

River House, Southeast Utah

Fremont Cottonwood (Populus fremontii)
along the San Juan River, Southeast Utah

The coolness of the alcove gives relief from the stifling heat.

The air is heavy and does not move.

Only the crystal note of the canyon wren breaks the stillness,

a long gliss of sound, starting high and falling, never ascending.

A signal perhaps, or just a burst of appreciation for the midday refuge.

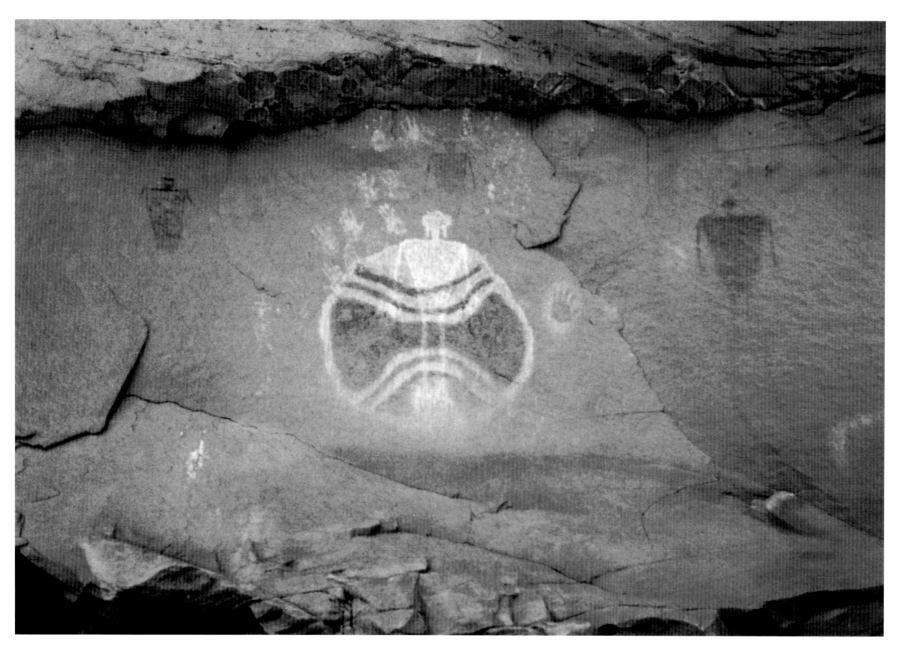

Baseball Man pictograph, Chinle Wash, Southeast Utah

Jailhouse Ruin, Grand Gulch Archaeological Area

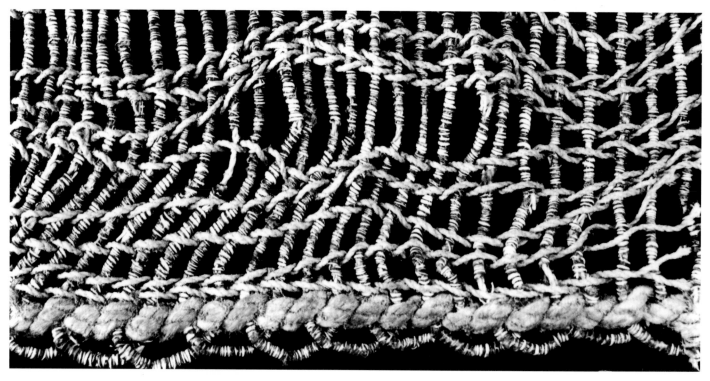

*Turkey feather blanket, Edge of the
Cedars State Park Museum*

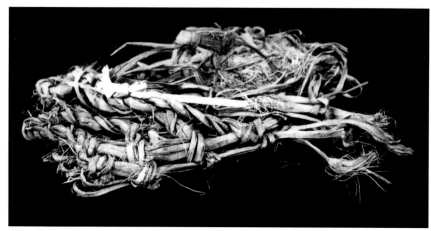

Eight thousand year-old Archaic sandal, Edge of the Cedars State Park Museum

A people of intelligence lived here.

Ancient ones with a passion and respect for natural order,

who used everything available in ways learned over a great time,

creating a marriage of artistry and necessity.

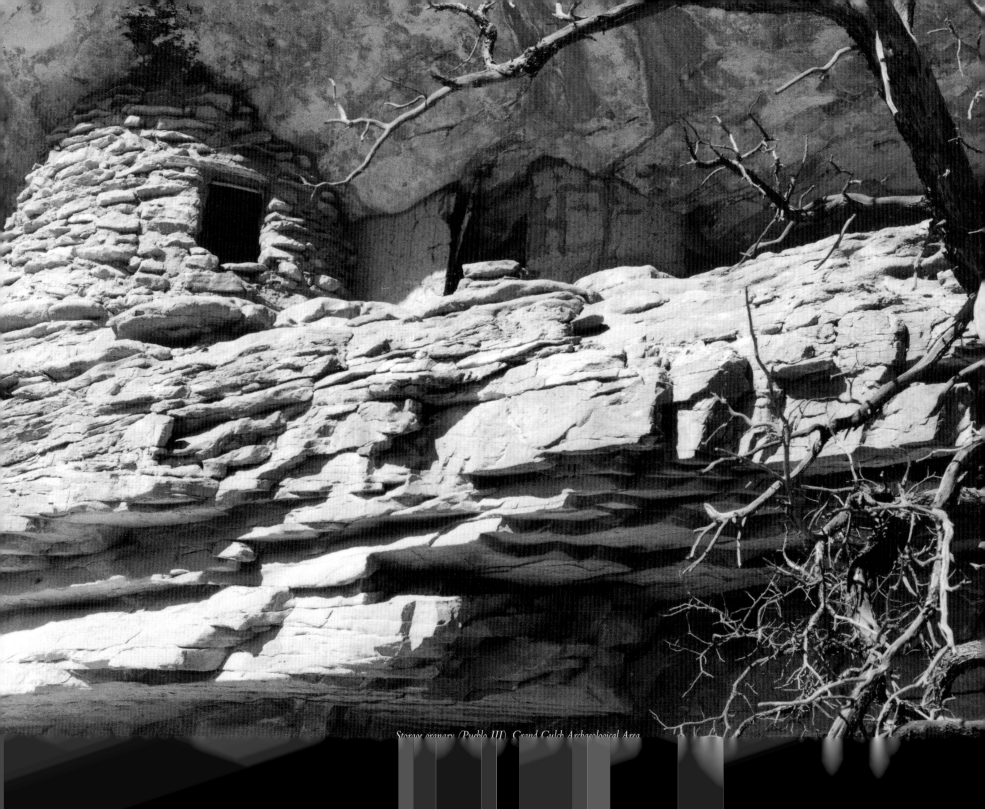

Storage granary (Pueblo III), Grand Gulch Archaeological Area

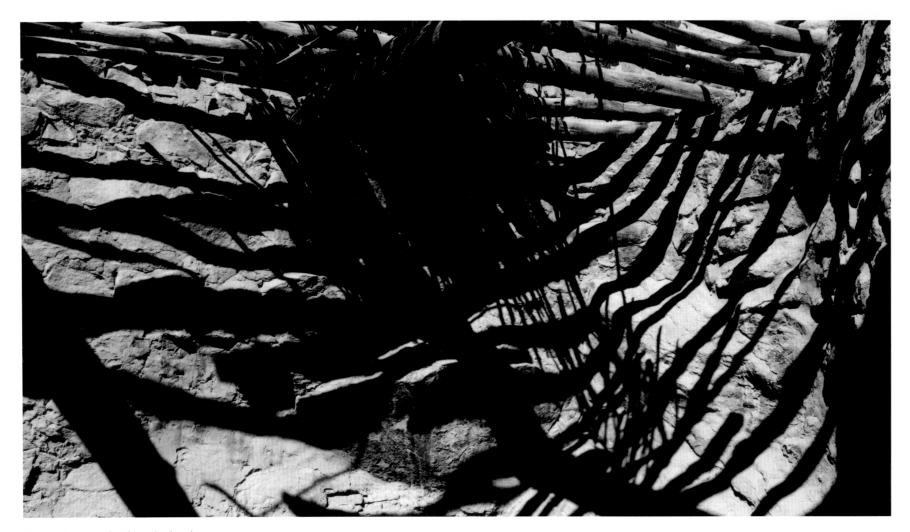

Kiva Shadows, Grand Gulch Archaeological Area

The wind gusts again stirring the now dry cottonwoods.

A blizzard of gold and brown falls littering the ground.

Potsherds everywhere.

The wind kicks up a sheet of sand and leaves, exposing still more.

Exquisite. Broken.

Back to the Earth as their makers moved on.

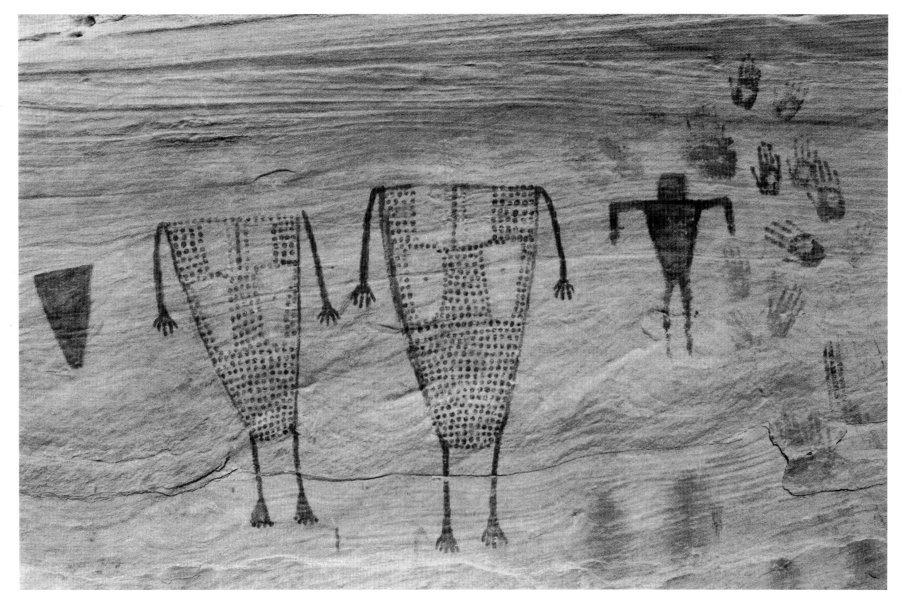

Anthropomorphic pictographs at Green Mask Ruin, Grand Gulch Archaeological Area

Sunrise window, Pueblo del Arroyo, Chaco Culture National Historical Park

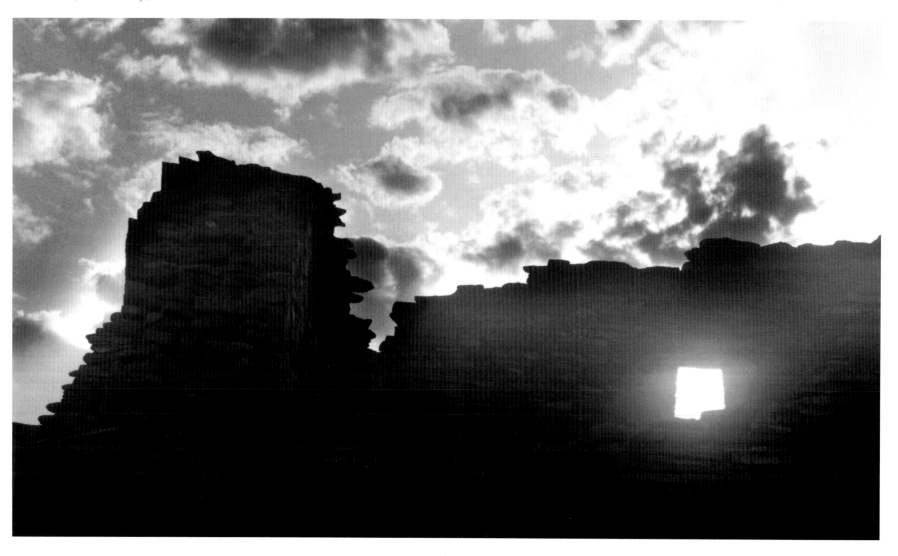

Ancient Space and Time in the Canyons

J. McKim Malville

Across the mesas and canyons once inhabited by the Ancestral Puebloans there are places that mark the sun at summer and winter solstice. These are locations where people could celebrate the returning cycles of the sun and thereby achieve a certain parallelism with the forces that govern earth and sky. At the solstices the repetitive nature of those forces becomes especially obvious, and one can easily sense connections to past solstices. Every winter solstice the sun rises at exactly the same place on the horizon and casts the same shadows across ancient petroglyphs on the canyon walls. Solstice suns cycle into the past and into the future, seemingly without limit. Past and future time merge with the present.

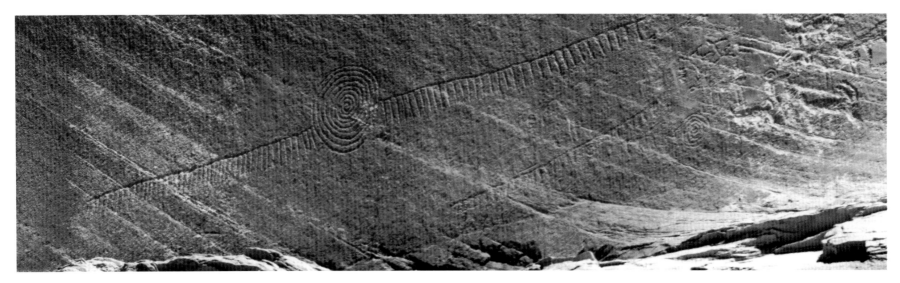

Lunar Calendar pictograph, Southeast Utah

SACRED TIME AND SPACE

For many cultures cyclic time is synonymous with sacred time. Cycles of time establish the dates of periodic festivals, which may provide access to the "Great Time" when gods and ancestors walked the earth. Keith Critchlow, the British scholar of sacred architecture, speaks of cyclic time as a "bridge to eternity," a passageway from transitory time to timelessness.

Festivals are separated by days of ordinary time, like blank packaging material. Both kinds of time are needed and both are inscribed on calendars, be they modern wall calendars or ancient petroglyphs. A festival needs to be anticipated, and the number of ordinary days until a winter solstice festival must be counted in a linear fashion and marked, one by one, on a calendar stick or by tick marks on a wall.

The ancient residents of Chaco Canyon, Mesa Verde, and elsewhere in the Pueblo Southwest must have lived within such a combination of sacred and ordinary time. There were special places as well as special times for entering the world of the ancestors, locations where earth, sky, and underworld appear to meet. Such sacred and powerful places may have been Chaco Canyon and the Grand Canyon. Within Chaco Canyon, skyward-thrusting Fajada Butte may have been understood as a powerful place where earth and heaven come together. Every kiva shares that symbolism. Sunk in the ground, often with a sipapu in its floor, its walls are the earth, its dome is the sky, and its floor is the ceiling of the world below. Through a hole in its dome the ancestors emerged into our world in the realm of sacred time.

66 ☾

Ritual reenactment of creation may have occurred in the great kiva of Casa Rinconada in Chaco Canyon as actors emerged from the dark subterranean passageway coming in from the north.

The power of Casa Rinconada continues even today as hundreds of visitors gather at summer solstice to watch a beam of sunlight slowly move toward a niche on its interior wall. What people see today may be different from that experienced in the eleventh century. The niche may have been covered with a plastered screen of woven willow branches, and the window that allows sunlight to enter may not have existed. Today, everyone who watches the movement of the solstice sunlight knows exactly what will happen, but they still remain until the drama is completed. Among many of the modern onlookers there seems an unspoken sense of participation in the rhythm of nature and confirmation that all is well with the universe. In their quietness there also seems to be a continuing respect for the sacredness of that moment and of the place itself.

The three-slab site near the top of Fajada Butte is emblematic of the attention that the Chacoans paid to the cycles of the sun and moon. We know of no other place in the ancient world that combines so concisely the annual cycle of the sun and with the

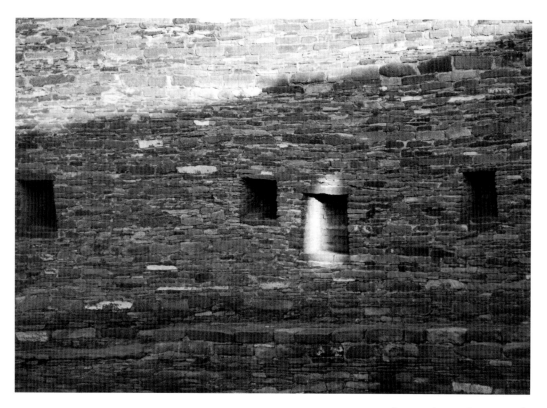

Summer solstice at Casa Rinconada,
Chaco Culture National Historical Park

longer cycle of the moon. Time has been collapsed onto space in its spiral petroglyphs. The area in front of the three slabs is not a place for large public ceremonies, but some privileged people must have entered its sacred space by means of the great ramp that provided access to the top of the butte. High above the public plazas and great houses on the floor of the canyon, celebrants may have engaged in a ritual regeneration of time and celebrated special events in the cycles of the sun and moon.

Especially at the solstices Chacoans must have felt themselves closely connected to the cosmos

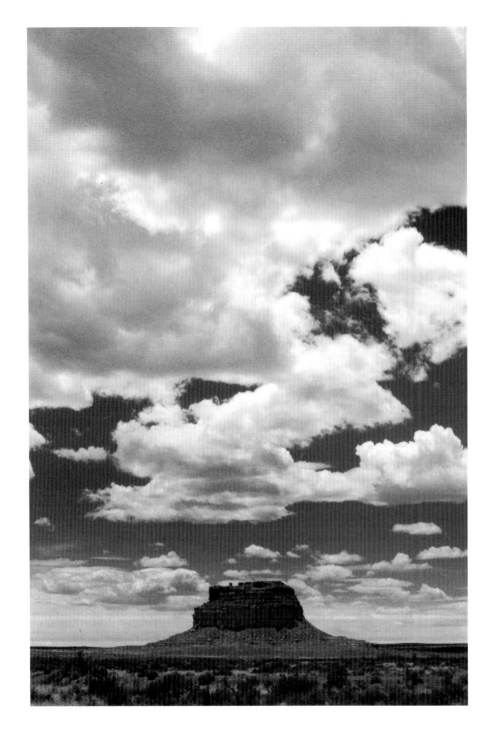

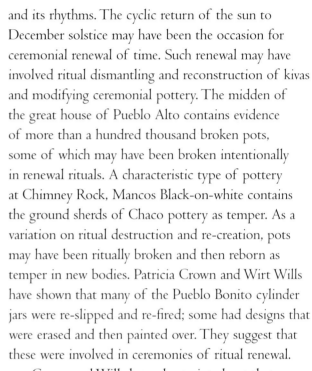

and its rhythms. The cyclic return of the sun to December solstice may have been the occasion for ceremonial renewal of time. Such renewal may have involved ritual dismantling and reconstruction of kivas and modifying ceremonial pottery. The midden of the great house of Pueblo Alto contains evidence of more than a hundred thousand broken pots, some of which may have been broken intentionally in renewal rituals. A characteristic type of pottery at Chimney Rock, Mancos Black-on-white contains the ground sherds of Chaco pottery as temper. As a variation on ritual destruction and re-creation, pots may have been ritually broken and then reborn as temper in new bodies. Patricia Crown and Wirt Wills have shown that many of the Pueblo Bonito cylinder jars were re-slipped and re-fired; some had designs that were erased and then painted over. They suggest that these were involved in ceremonies of ritual renewal.

Crown and Wills have also pointed out that as many as 70 percent of the thirty kivas that were excavated by Neil Judd in Chaco Canyon in the 1920s had been constructed on earlier kivas or had been substantially modified. Most frequently the walls of the earlier kiva were torn down to the level of the interior bench, and then a new kiva was rebuilt at a higher level. Reconstruction was also a characteristic of both small and great kivas at Pueblo Bonito, Chetro Ketl and Pueblo del Arroyo. Kiva G at Chetro Ketl had eight such rebuilding events. Tree ring dates indicate that reconstruction occurred on the average of every twenty years.

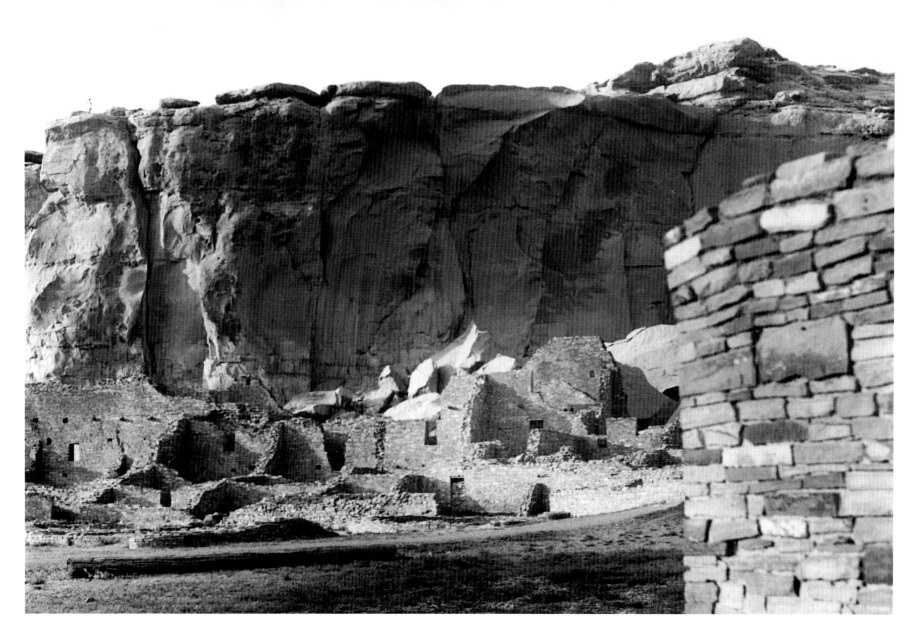

Chetro Ketl, Chaco Culture National Historical Park

Such a time span is intriguingly close to the lunar standstill cycle of 18.6 years. At Chimney Rock the east kiva of the great house was built and then reconstructed at the times of major lunar standstills. Another example of destruction and rebirth is provided by the tri-wall structure of Pueblo del Arroyo, which may have been the last major structure built in Chaco. It was razed soon after completion around A.D. 1010, and a similar structure was built at Aztec, the Hubbard tri-wall. Lekson suggests that such de-construction and rebuilding may have also signified the transfer of political power and ceremonial preeminence out of Chaco and its rebirth in Aztec. That cultural watershed occurred between A.D. 1125 and 1150.

Among the Aztecs of Mexico the major cycle of cosmic creation and destruction was established by the interactions between their sacred and secular calendars. The Aztec New Fire ceremony, which occurred every fifty-two years, involved a ceremonial rekindling of the sacred fire in the chest cavity of a sacrificial victim on the summit of the Hill of the Star. All fires had been extinguished in Tenochtitlan. All household pottery had been smashed, and the old images of gods had been thrown into the lake. In that ominous darkness, the world was returned to primordial chaos. The new fire was lighted in November at the precise time when the Pleiades reached the zenith of the heavens and appears to have been a metaphor for the creation of order out of darkness and the regeneration of time.

The extinguishing and the rekindling of ceremonial fires are some of the world's oldest winter solstice renewal rituals. One of the most dramatic places for such a fire in the Four Corners region would have been a great fire pit at the tip of the high mesa of Chimney Rock. A ceremonial fire may have been lit on the solstices, and a very special fire ceremony could have occurred at the time of major lunar standstill. The location of the fire pit is such that a fire would have blazed just in front of the full moon rising between the twin towers at winter solstice. The message of that first fire of the new cycle of sun and moon could have been passed southward to Pueblo Alto via the summit of Huerfano Peak. Along the North Road near Pierre's site, another fire on the summit of El Faro could have been viewed from Pueblo Alto.

Modern Pueblo traditions give us a glimpse into the Ancestral Pueblos' understanding of space and time. According to the anthropologist Alfonso Ortiz, the Tewa people attach no particular importance to historical and linear time. Pueblo people attempt to be part of cyclic, rhythmic time, which they understand to be a pattern of endlessly repeating cycles, similar to the seasonal birth and death of plants. Plants are born and they die, but the pattern remains. This metaphor of plant life is also expressed in the belief that ultimately all beings emerged from mother earth.

Tewa tradition also involves the extraordinary symbolism of the "spatialization" of time, a turning

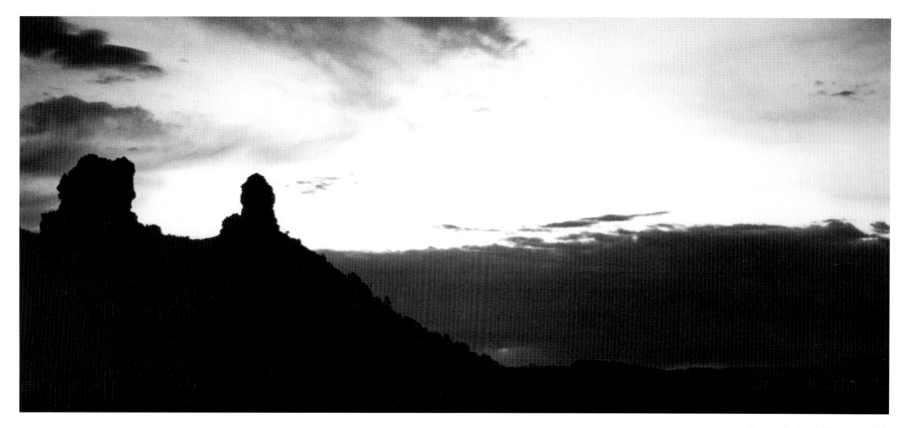

Chimney Rock and Companion Rock,
Chimney Rock Archaeological Area

of time into space. Events of sacred time are anchored onto particular locations of sacred space. Since space is everywhere present and simultaneously existent this approach provides a powerful metaphor for ever-present and simultaneously existent time. As events receded into time they were likely to be organized into sets of four spatial elements: four sacred mountains, a distance of four days of travel, four seasons, and four directions of space. Anything that occurred beyond the four sacred mountains was likely to be placed in a set of twelve.

This conversion of time into space has a remarkable resemblance to our concept of space-time in modern physics. Both time and space can be subdivided into linear segments. Seconds and centimeters are parallel dimensions that are fundamentally similar. Although space can be traversed backwards and forwards, we do not seem to have that freedom of choice in time. The Tewa concept goes beyond physics and envisions time as an ever-present landscape that can be traversed back and forth on special occasions.

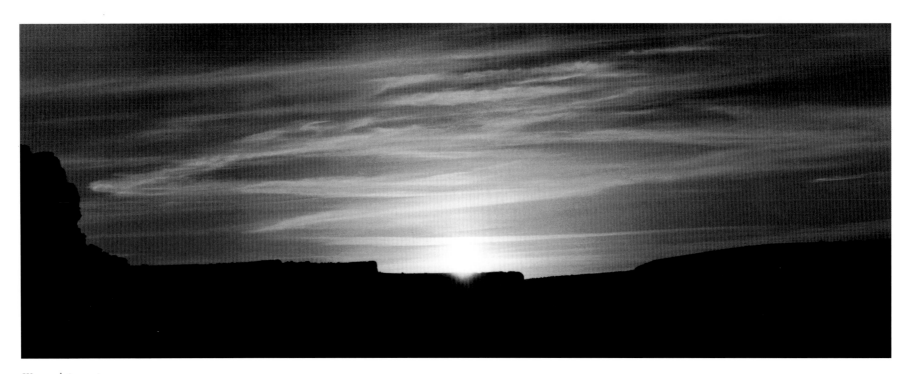

Winter solstice sunrise,
Chaco Culture National Historical Park

CALENDARS AND PUBLIC FESTIVALS

Time is both sacred and practical. It emerges mysteriously from the heavens and shares the power and sanctity of the celestial dome. As one of humankind's great inventions, the calendar may have been reinvented independently many times throughout human history. The Chacoan horizon calendar, which utilized the precise location of the sun at sunrise or sunset, appears to have been an entirely local invention; no similar horizon existed in the jungles of the Yucatán.

The horizon calendar was probably primarily a ritual and ceremonial device rather than an agricultural tool. In the Chaco basin, the year-to-year variations in soil moisture are too great for planting to be determined by the motion of the sun along the horizon. Dates of planting have to be established by the experiences of an on-the-spot farmer and not by abstract time determined by movement of the distant sun.

In order get large numbers of people gathered together over great distances for a ceremony, ritual, or festival, an accurate calendar shared by the entire community was an absolute necessity. An accuracy of a few days would have been needed in order for everyone to arrive at the same time. When travel of one to two weeks is involved pilgrims would need to know when to depart from their homes to avoid wasting time waiting at the destination or missing

the festival entirely. As a symbolic sipapu that witnessed the emergence of the ancestors from the worlds beneath ours, Chaco would have been an appropriate place to celebrate the birth of the world at winter solstice. Pilgrims may have walked along roads that led inward to the center. The great houses may have filled with pilgrims for periodic festivals. As a form of ritual descent into the sipapu of the Canyon some of the pilgrims may have descended the steep stairways cut into its walls. At the end of the ceremonies, the celebrants may have emerged from the Canyon, as if emerging from the earth, climbing those precarious stairways.

There is irony in the fact that within Chaco Canyon there are few opportunities for making precise observations of the sun or moon on the horizon. Perhaps more so than any other area in the Four Corners region, Chaco was a place that needed a precise calendar to get pilgrims to festivals on time. As seen from most of the great houses in the Canyon, the horizon is too smooth to allow direct calendrical determinations using the natural horizon throughout the year. Artificial calendrical devices seem to have been constructed at Pueblo Bonito, Casa Rinconada, and the three-slab site of Fajada Butte, but these could have been established only after appropriate dates had been obtained

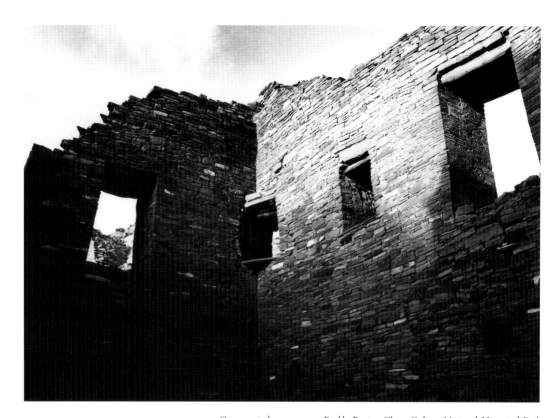

Corner window at sunset, Pueblo Bonito, Chaco Culture National Historical Park

from direct observations of the position sun on an irregular horizon obtained at a calendrical station.

A calendrical station needs an irregular horizon that allows precise determination of the position of the rising or setting sun. It should be conveniently located close to habitation for easy access by a keeper of the calendar, and it should provide an opportunity for both anticipation and confirmation of dates of festivals. There are several places in the Canyon where calendrical stations could have provided an approximately two-week anticipation of summer or winter solstice.

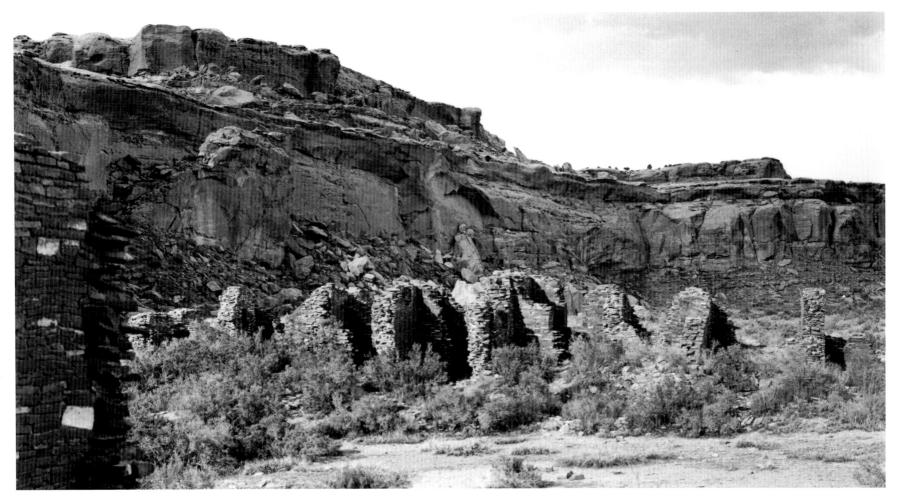

Wijiji, Chaco Culture National Historical Park

A spiral petroglyph on the northeast face of Piedra del Sol, near the Una Vida great house, may have been the source of the dates that were needed to position the spiral petroglyphs on Fajada Butte. On June 4–6, a pyramidal rock on the horizon casts a triangular shadow across the center of the spiral. Because of the diffuse edge of the shadow, the position of the shadow on the spiral petroglyph cannot be used as a precise day marker. However, a priest or calendar-keeper standing just in front of the center of the spiral can make direct observations of the sun with a precision of one or two days, both to anticipate and confirm the day of summer solstice.

74 ☾

CALENDRICAL STATIONS

Summer Solstice	Winter Solstice	Equinox
Piedra del Sol	Wijiji	Chimney Rock from the
Chimney Rock:	Kin Kletso	Piedra Overlook
from the Sun Tower		

The great house of Wijiji, built around A.D. 1110, provides an excellent primary calendrical station for winter solstice. As viewed from the northwest corner of the house, throughout the fall the rising sun moves slowly toward a clearly defined notch on the southeastern horizon. It rises at the northern edge of the notch on December 4–5, providing thereby an opportunity for precise anticipation of winter solstice. Confirmation of winter solstice occurs when the sun reaches the southern edge of the notch. This site may have functioned as a calendrical station prior to the construction of the great house, and such calendrical activity may have been partly responsible for the particular location of that great house.

Another opportunity for anticipation and confirmation of winter solstice is at the great house of Kin Kletso, constructed between A.D. 1125 and 1130. Again there is a sixteen to seventeen day opportunity for anticipation and confirmation of winter solstice

when the sun rises at the base of the prominent cliff to the southeast. When viewed from the north wall of the great house, the sun appears at the cliff base on December 4–5. From the south wall of the great house, the rising sun at solstice appears just at the base of the cliff. The large boulder that is incorporated in the western portion of the building may also have served as a sun-watching site before construction of the great house.

The day of equinox is marked at the three-slab site of Fajada Butte by a dagger of light passing through a smaller secondary spiral. The most precise timing of equinox could have come from Chimney Rock, where the major site of the Piedra Overlook, 5AA8, is built due west of the gap between the chimneys. Residents of that site would have been greeted with spectacular sunrises on equinox. Announcement of that sunrise could have been passed directly to the Chimney Rock Pueblo and then down to Pueblo Alto via Huerfano Peak.

Hierophanies of Space and Time

The repetitions of cyclic time provide intuitions of a realm beyond ordinary time, which may arrive as hierophanies or "manifestations of the sacred." The historian of religion, Mircea Eliade, is responsible for the application of this term to the wide-ranging human encounters with the sacred. Both places and times may be the stages for hierophanies.

> *The sacred manifests itself as a power or force that is quite different from the forces of nature. A sacred tree, for instance, is not worshiped for being a tree. Neither is a sacred stone adored, in and of itself, for its natural properties as a stone. These objects become the focus of religious veneration because they are hierophanies, revealing something that is no longer botanical or geological, but "wholly other."*
>
> *. . . the acts of hierophany are repeated in the sacred calendar of each year. Rituals that repeat the moment of a hierophany re-create the conditions of the world in which the sacred originally appeared, and at that moment when the sacred manifests itself again in the same way, extraordinary power overwhelms the profane succeeding of time. . . . Any fragment of time (e.g. the phases of the moon, the transition of the human life cycle, the solstices, the rainy seasons, the breeding cycles of animals, the growth cycles of plants) may at any moment become hierophanic.*
>
> (Eliade and Sullivan 1988)

A hierophany can be an unusual stone or geological formation, such as Chimney Rock, Fajada Butte, and Towaoc. It becomes doubly powerful if associated with a significant "fragment of time." Hierophanies may also be established by well-designed architecture.

Built in 3200 B.C., Newgrange outside of Dublin is one of the oldest hierophanies involving the winter solstice sun. It is also one of the most spectacular, providing many visitors from the twenty-first century a sense of the power and magic of a hierophany. The nineteen-meter passageway leading to the center of the shaft tomb is sufficiently narrow that when artificial lights are extinguished at the center, the space is plunged into nearly total darkness. For five days around winter solstice a beam of light works its way down the shaft to illuminate the inner chamber, and at other times of the year visitors are treated to a dramatic simulation of sunrise staged by the guide.

The sun has been a major source of hierophany as Huitzilopotchli in Mexico, Inti among the Inca, and Ra in Egypt. A dramatic Mayan hierophany occurs at the Castillo of Chichen Itza when moving light and shadow on its balustrade form an undulating image of a serpent, which is viewed by thousands of spectators around the days of equinox.

The twin spires of Chimney Rock are considered to be a shrine to the Twin War Gods by the Taos Pueblo. In addition to the sacred dimension of these spires themselves, every 18.6 years the moon provides a spectacular backlighting of the Chimney as viewed from the high mesa. From the great house of the

Chimney Rock Pueblo, the moon can be viewed to rise in the gap between the towers in dark skies in two or three fall seasons around the major standstill. The most spectacular hierophany at Chimney Rock occurs at winter solstice every 18.6 years when the full moon rises at sunset between the double spires.

The great house of Peñasco Blanco at the northwest corner of Chaco Canyon provides another view of the major standstill moon rising along the length of the Canyon. That moonrise is doubly significant because it appears over Pueblo Bonito, the largest of the great houses.

The Chimney Rock great house provides a solar hierophany that is assisted by architecture. On the morning of summer solstice the sun rises along the north wall of the great house when viewed near the bedrock basin on the high mesa. Closely associated with Chaco Canyon, Chimney Rock was abandoned around A.D. 1125, at the time when the influence of Chaco was faltering. It is extraordinarily interesting that in the new power center of Aztec the north wall of the great house of Aztec West should be oriented along the sight line to the rising sun of summer solstice. These are the only two great houses that appear to have orientations to summer solstice. That the two should share a summer solstice hierophany is suggestive of the influence that Chimney Rock may have had upon Aztec ceremonialism.

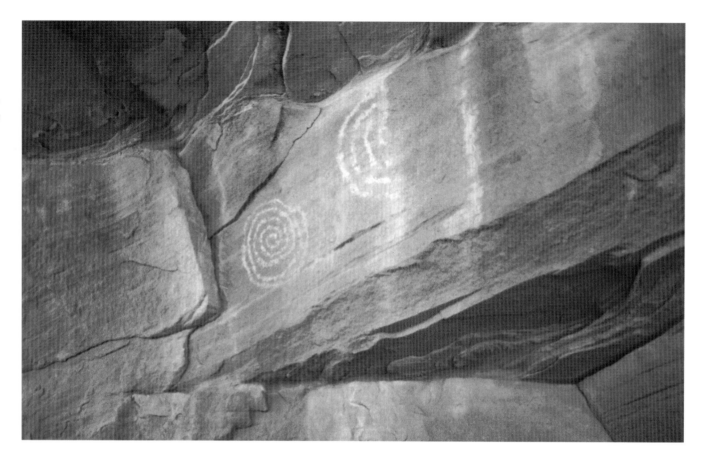

Solstice marker at Holly Ruin,
Hovenweep National Monument

Another possible example of influences radiating outward from Chimney Rock is provided by the major standstill moon setting over Sun Temple at Mesa Verde as viewed from the four-story square tower of Cliff Palace. These structures were probably built a half century after the abandonment of Chimney Rock, at a time when Mesa Verde may have been under the influence of Aztec. The double circular structures in the Sun Temple may have been attempts to replicate the twin towers of Chimney Rock. In addition to the lunar event, every winter solstice the sun sets over Sun Temple as viewed from a platform containing a pecked basin at the southern end of the Cliff Palace enclosure.

Further to the west of Mesa Verde is Yucca House on the lower east slope of the Sleeping Ute Mountain, where another post-Chacoan solstice hierophany occurs. Yucca House is located some ten to fifteen miles south of the major population

Bedrock grinding areas at Perfect Kiva,
Grand Gulch Archaeological Area

centers of the Canyons of the Ancients National
Monument. The great house commands a strategic
position between those agriculturally rich lands and
the drier and less fertile Chaco Basin. Virtually all
movement in that corridor would have been visible
to the residents of Yucca House, which may have been
partly responsible for the particular location of the
great house. To the southwest of Yucca House rises
the dramatic spire of Towaoc on the south flank of
Sleeping Ute Mountain. The winter solstice sun sets
over Towaoc as viewed from top of the great house
of Yucca House.

A hierophany of light and shadow in the
southwest occur at Holly House in Hovenweep
when at morning near summer solstice a horizontal
spear of light crosses a rock face containing
petroglyphs of a serpent, spirals, and concentric
circles. This event is similar to that of the three-
slab site on Fajada Butte except that is it more
accessible and is visible to a larger audience.

SOLSTICE HIEROPHANIES (BEFORE AND AFTER ~ A.D. 1125)

Summer solstice	Winter solstice
Chimney Rock: Sun Tower—sunrise	Fajada Butte—midmorning
Chimney Rock: North wall of great house—sunrise	Chimney Rock: sun tower—sunrise
Casa Rinconada: niche—sunrise	Pueblo Bonito: corner window—sunrise
Fajada Butte—midmorning	
Hovenweep Castle—sunset	Cliff Palace: Sun Temple—sunset
Holly House—sunrise	Yucca House: Towaoc—sunset
Yellow Jacket: solar monolith—sunrise	Yellow Jacket: great kiva—sunrise
Aztec: north wall of great house—sunrise	Grand Gulch: Perfect Kiva—sunrise

LUNAR HIEROPHANIES

Chimney Rock: moonrise between the Chimneys viewed from the great house backlighting of the Chimneys viewed from the bedrock basin

Fajada Butte: major and minor standstills marked on the spiral petroglyph

Mesa Verde: moonset over the Sun Temple viewed from the four-story square tower

Peñasco Blanco: moonrise along the Canyon

In sites in Grand Gulch such as Green Mask, Junction, Split Level, Turkey Pen, and Perfect Kiva there are hundreds of bedrock grinding areas and associated pecked basins. Some of the grinding areas may have been used for grinding of domestic corn or sharpening of axes, but many are far from habitation sites and are located on exposed boulders that would not be appropriate for grinding corn for domestic purposes. Some may have involved ritual grinding of corn, sherds, or semi-precious stone for offerings to the rising sun to be placed in adjacent basins. The Perfect Kiva enclosure contains forty-six pecked basins and approximately forty grinding areas of which many are oriented to the rising sun at winter solstice. The natural acoustics of this enclosure are such that a chorus of grinding would have created a dramatic ceremony for bringing up the sun. This combination of bedrock grinding area and basin are also found at Mesa Verde and on the side of Piedra del Sol that faces winter solstice sunset.

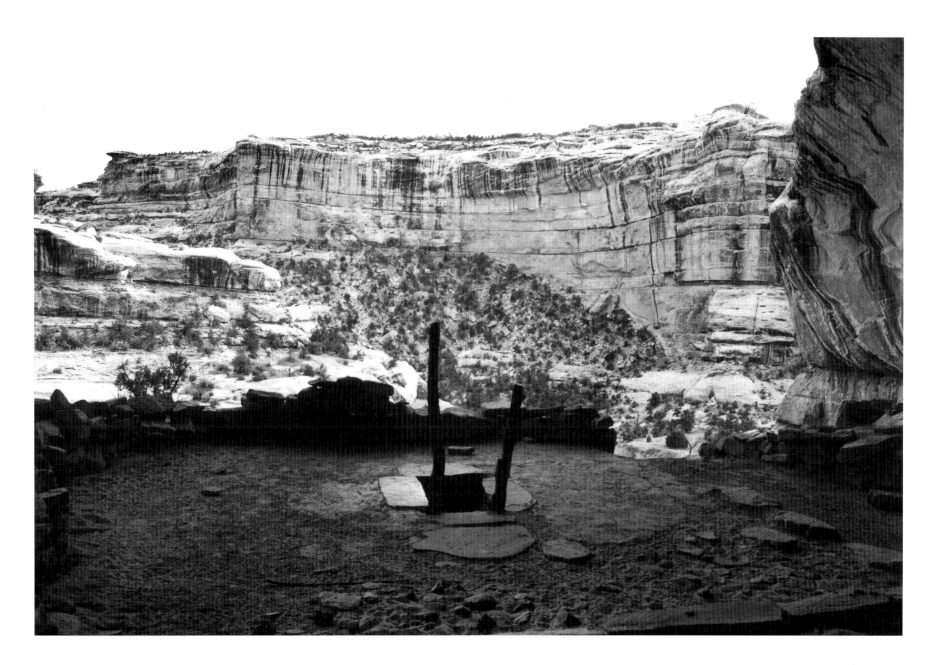

Solar corona petroglyph at
Piedra del Sol, Chaco Culture
National Historical Park

UNEXPECTED DISPLAYS OF THE SACRED

In addition to these events that are predictable because of their periodicity, there are hierophanies that are completely unexpected and potentially frightening. The total solar eclipse that crossed Chaco Canyon in July of A.D. 1097 could have been one such display of sacred power. Chacoan astronomers who may have been observing the cycles of the sun and the moon for more than half a century would have been caught unprepared for such an event, which occurs at new moon rather than a full moon. Chacoans had observed many lunar eclipses in the Canyon, but they probably had no cultural tradition involving a total solar eclipse. The last total solar eclipse in the Canyon had occurred more than two centuries earlier in A.D. 875. Lasting for four minutes in mid-afternoon when the sun was high in the sky, the total solar eclipse may well have terrified the whole community. It may have been recorded as a petroglyph on the south face of Piedra del Sol in Chaco Canyon. The curved structures in the petroglyph are similar to the structure of the solar corona when there is an eruption of matter, known as a coronalmass ejection.

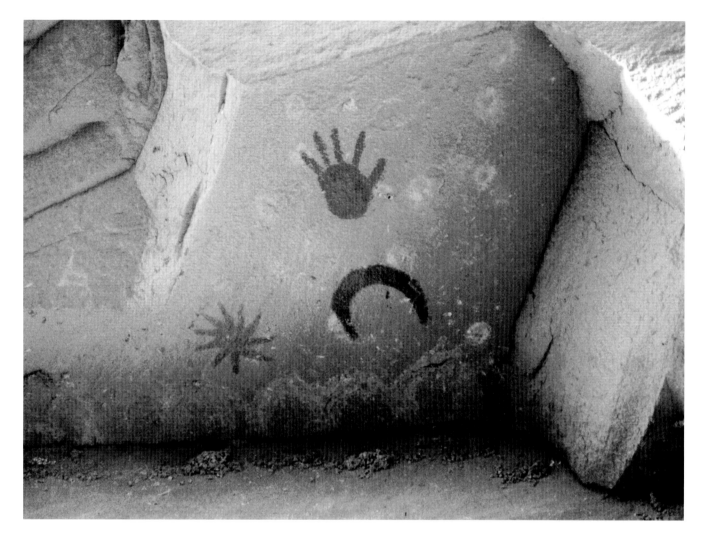

Another potentially frightening event would have been the appearance of the Taurus supernova in A.D. 1054. The newly visible star, resulting from a supernova explosion, was so brilliant that it was visible during the day for two weeks. Since it occurred only two weeks after summer solstice (July 4), sun watchers awaiting sunrise could have easily spotted the supernova on the first day of its spectacular life. Chinese and Middle Eastern astronomers reported that it exceeded the brilliance of Venus, and some claimed that it rivaled the moon. For about three weeks it was visible in the daytime sky, which would have been an astonishing sight. It continued as a slowly fading star for about two years, until it fell beyond the reach of the unassisted human eye.

Non-cyclical Hierophanies

Taurus Supernova	1054
Eruption of Sunset Crater	1064
Halley's Comet	1066
Total solar eclipse	1097

It is possible that the supernova is represented on the canyon wall below Peñasco Blanco as a star next to the crescent moon. The great house of Chimney Rock may also mark the supernova. The southern wall of the building is approximately in line with its rising position as viewed from the bedrock basin near the great kiva of the high mesa.

Twelve years later, in A.D. 1066, Halley's Comet appeared in skies over Chaco, and it, too, may be represented as a pictograph on the wall below Peñasco Blanco. This was perhaps the most famous visit of the comet when it terrified millions of Europeans and may have influenced the outcome of the Battle of Hastings.

Just two years before this appearance of Halley's Comet another strange phenomenon appeared in the skies of A.D. 1064 in the form of a great thunderhead produced by the eruption of Sunset Crater near Flagstaff. As Steve Lekson describes it, this dramatic thunderhead wouldhave been a source of wonder and fear for most of the Southwest. "Lightning flashed day and night through the ash-laden clouds; the thunder was drowned out by the rumble of volcanic explosions." This would have been another good candidate for a manifestation of sacred power. Although visible from Chaco Canyon, there is no record of its appearance that we have been able to decipher.

Summer sunset, Hovenweep Castle,
Hovenweep National Monument

FINAL REMARKS

The years between the supernova of A.D. 1054 and the total eclipse of A.D. 1097 spanned the height of Chacoan culture Because of the extraordinary celestial events of the last half of the eleventh century, the residents of the Canyon and its outlying communities may have been especially attentive to displays of power in the heavens.

The sky needed to be watched. The adage, "the sky determines" included both sun and moon but also it included the precious water needed for survival. The decade-long drought in the A.D. 1130s that occurred near the end of construction in Chaco Canyon may have caused the migration of leaders northward to Aztec. The design and symmetries of the greater Aztec suggest elaborate ceremonialism, which may have been a robust echo of Chacoan ritual activity. Contemporaneous settlements at Mesa Verde, Yucca House, Hovenweep, and Yellow Jacket have evidence of solstice hierophanies.

Other than the alignment of the north wall of the great house to summer solstice sunrise, there is no evidence of calendrical activity at Aztec. Interest in the sun clearly continued, but an accurate calendar for scheduling major ceremonies may not have been necessary. Eventually the sky again determined, and the drought of A.D. 1275–1300 probably was a factor eventual abandonment of Aztec and much of the Four Corners Region.

BIBLIOGRAPHY:

Critchlow, Keith. 1996. Time: The Mercy of Eternity. In *Concepts of Time, Ancient and Modern*, edited by Kapila Vatsyayan. New Delhi: Sterling Publishers.

Crown, Patricia L. and Wirt H. Wills. 2003. Modifying Pottery and Kivas at Chaco: Pentimento, Restoration, or Renewal? *American Antiquity* 68:511–32.

Eliade, Mircea. 1958. *Patterns in Comparative Religion*. New York: New American Library.

Eliade, Mircea and Lawrence E. Sullivan. 1987. Hierophany. In *The Encyclopedia of Religion*, edited by Mircea Eliade, vol. 6. New York: MacMillan Publishing Company.

Malville, J. McKim and Gregory E. Munson. 1998. Pecked Basins of the Mesa Verde. *Southwestern Lore* 64:1-35.

Malville, J. McKim and Claudia Putnam. 1993. *Prehistoric Astronomy in the Southwest*. Boulder: Johnson Books.

O'Kelley, M. J. 1982. *Newgrange*. London: Thames and Hudson.

Ortiz, Alfonso. 1977. Some Concerns Central to the Writing of 'Indian' History. *The Indian Historian* 10:17–22.

Sofaer, Anna. 1997. The Primary Architecture of the Chacoan Culture: A Cosmological Expression. In *Anasazi Architecture and American Design*, edited by Baker H. Morrow and V. B. Price. Albuquerque: University of New Mexico Press.

GALLERY THREE:
Protected Places

Photographs and Reflections
John L. Ninnemann

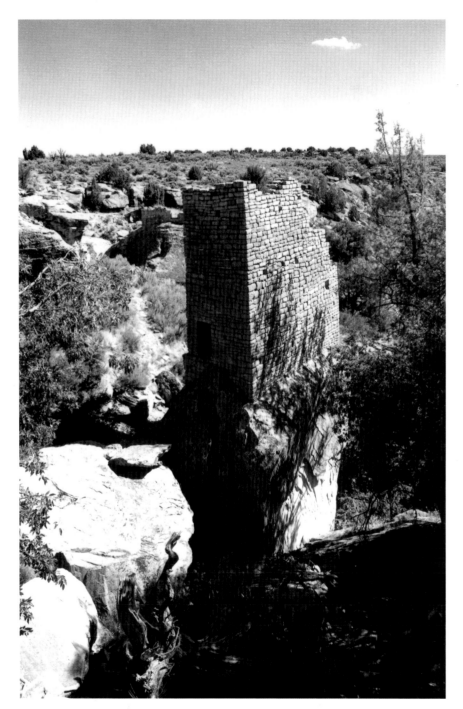

Boulder Tower, Holly Ruin,
Hovenweep National Monument

The spring of clear, sweet water is the reason for the tower,
a stone declaration of possession,
guarding life itself for the village under the cliff.
Pools of water still collect, now giving life to insect and bird,
and to a verdant thicket of cool and inviting poison ivy.

Long House, Mesa Verde National Park

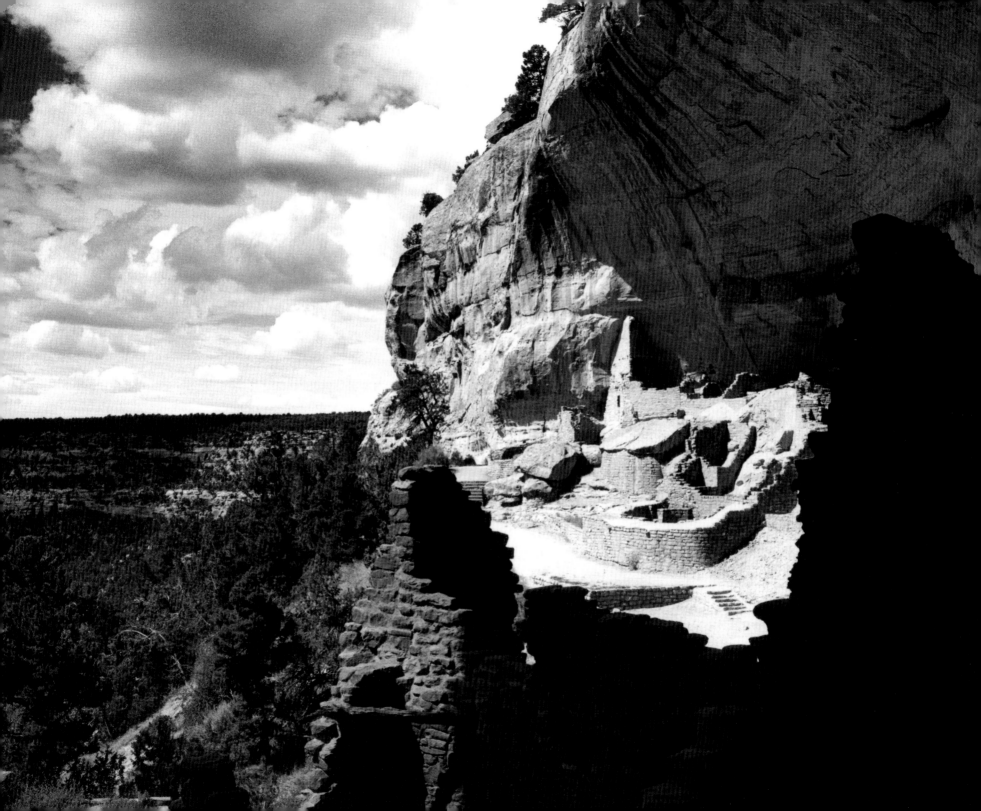

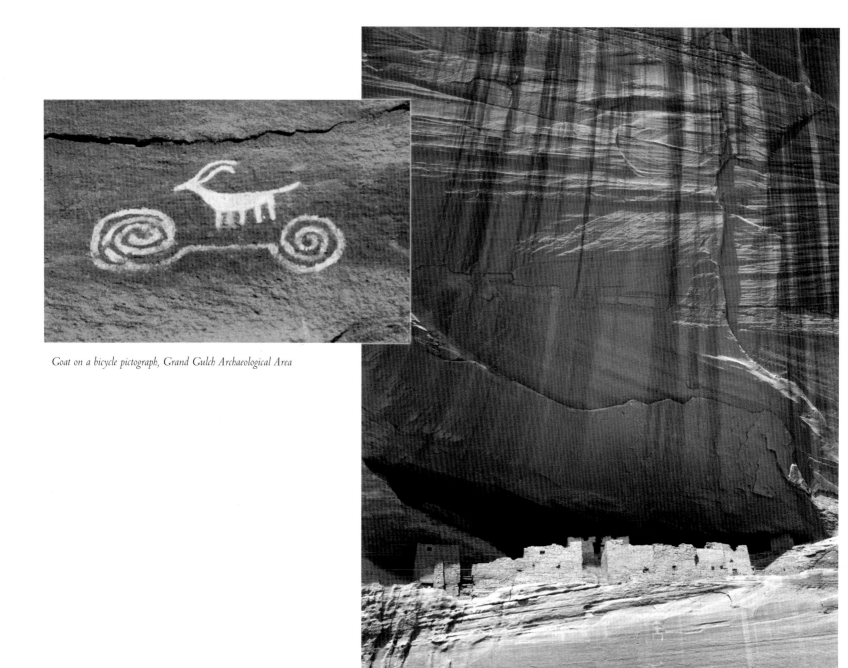

Goat on a bicycle pictograph, Grand Gulch Archaeological Area

White House, Canyon de Chelly

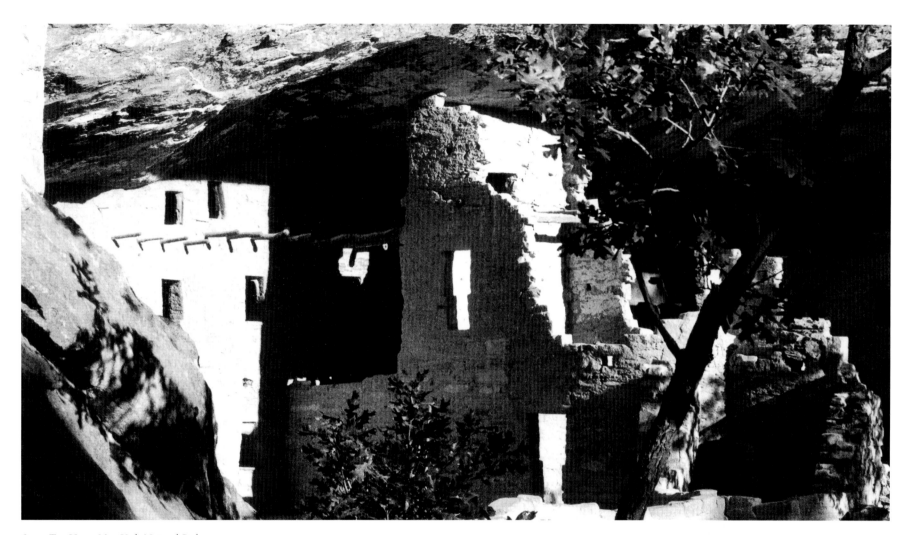

Spruce Tree House, Mesa Verde National Park

The Common Raven

(Corvus corax)

From high above the ruin, ravens dive off canyon rim into the cloudless sky.

Gliding. Rolling. Chasing.

Rasping out challenge and insult, then mock surprise.

They land briefly and dive again, pursuer becoming leader.

Playing as they did when this small city was full of life.

Kiet Siel, Navajo National Monument

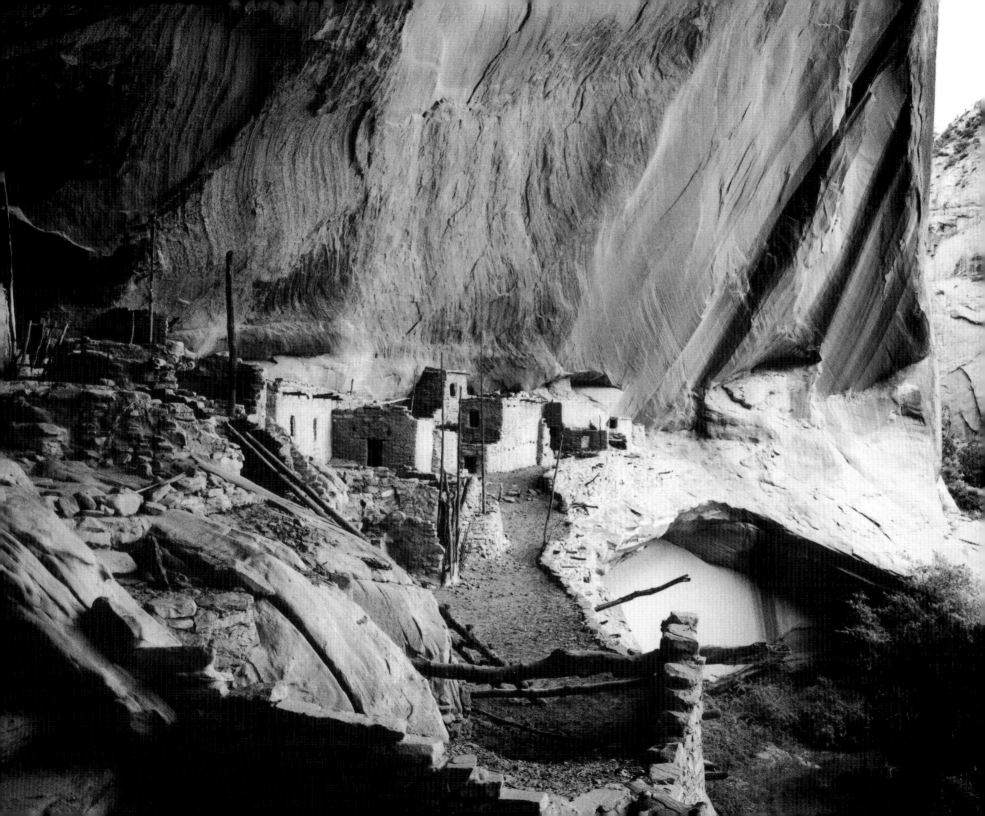

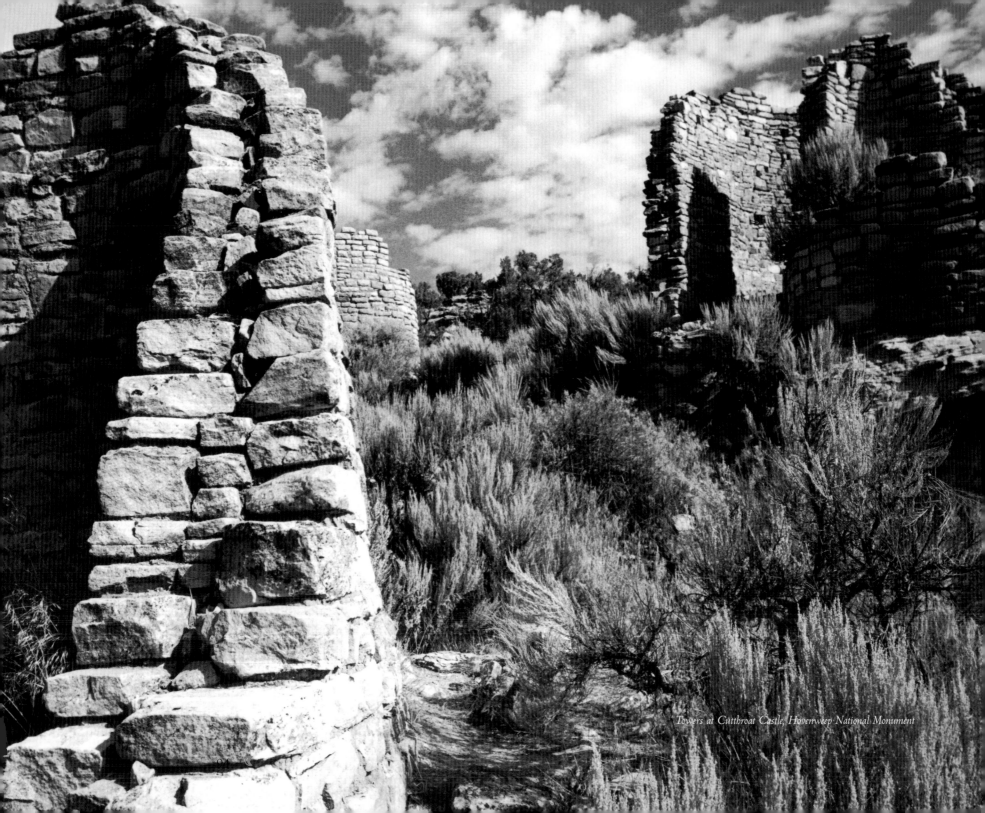

Towers at Cutthroat Castle, Hovenweep National Monument

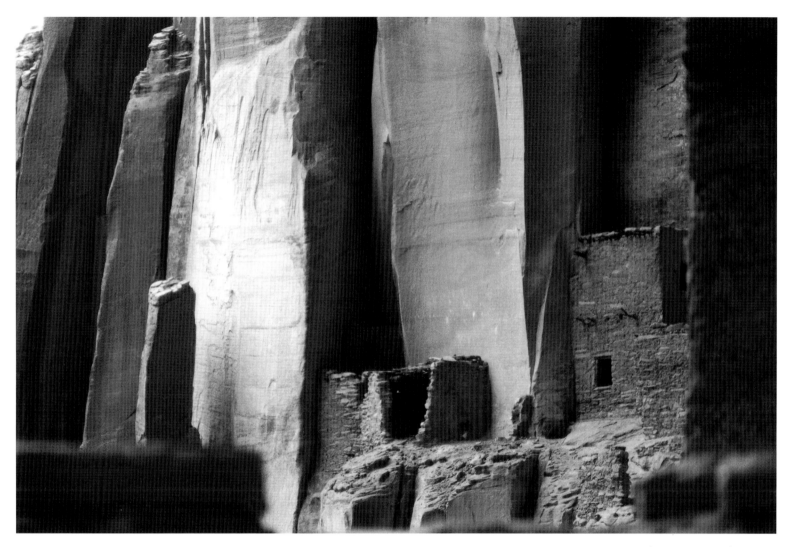

Betatakin, Navajo National Monument

Each block patiently shaped by stone hammers,
then carefully placed, defying gravity.
Mortar spread with still visible handprints,
creating signatures classified Pueblo I, II, and III,
all more durable than their architects.

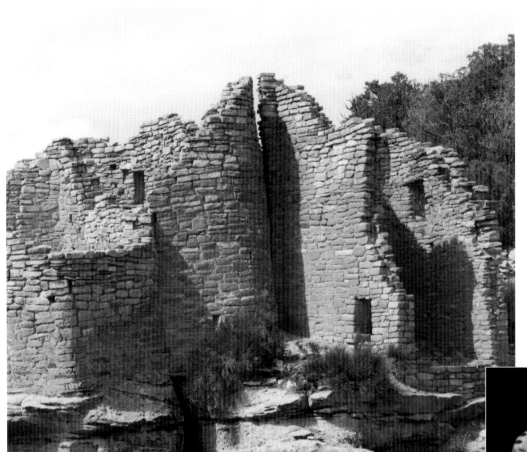

Cutthroat Castle, Hovenweep National Monument

Child's mug, Edge of the Cedars State Park Museum

Photo Details

Gallery opening photo
frontis and pages 13, 55 and 87
This carefully constructed masonry is part of the outside wall of the Western Pueblo at Aztec Ruins National Monument. Each sandstone block was pecked to achieve appropriately dressed surfaces, and decorated with horizontal bands of green stone, even though the final result was completely covered with a mud-based plaster.

☾

INTRODUCTION

page 1 *"Canyon Registry".* This pictograph panel consists of multiple handprints of organic pigment, which may have marked a gathering area or nearby settlement.

page 2 This braided adult "winter sandal" has side loops, a lacing cord, and a round toe. It is constructed of yucca leaves and juniper bark. The braided child's sandal has a square toe and a square heel, and is also made from yucca leaves. Both date from Pueblo III. Provenience: Turkey Pen Ruin, Cedar Mesa. From the Edge of the Cedars State Park and Museum collection.

page 3 Kiet Siel is said to be the largest and best-preserved Puebloan structure in Arizona. It consists of approximately 150 rooms, which reflect the arrival and departure of a variety of groups, each contributing variation to the design and structure. The extremely dry climate in this part of Arizona has facilitated the remarkable preservation of such things as basketry, corncobs, and sandals within the ruin.

page 4 The great ruin of Paquimé is located just outside (old) Casas Grandes in the Chihuahan desert of Northern Mexico. This site consists of many acres of plazas, a central ball court, and room blocks constructed of adobe punctuated by frequent T-shaped doorways.

page 5 The *Great Gallery*. These "Barrier Style" mineral pictographs are thought to date from Archaic times. This remarkably preserved panel in Horseshoe Canyon, Canyonlands National Park, contains a large collection of pictographs depicting human-like and animal figures, some larger than life size.

page 6 & 7 The *Procession Panel* of Basketmaker petroglyphs was first reported in 1990. The panel is approximately twenty feet wide and contains 179 figures, varying from four to eight inches high. These figures seem to proceed from three directions to a circle figure in the center of the panel. Alteration of the panel by additional chipping seems to have taken place in prehistoric times, rather than as a result of vandalism.

page 9 Pueblo Bonito is the largest of the "great houses" found in Chaco Canyon. It is thought to have been occupied as late as the 1200s. Its magnificent masonry was constructed in stages, eventually reaching four stories in height and over six hundred rooms and forty kivas.

page 10 This petroglyph panel is found high on the cliff above Montezuma Creek. It contains both animal representations, and two human-like, bird-headed figures engaged in combat. The bird motif is common in shamanic symbolism throughout the world, and the bird-headed man variation has been described as originating in Canyon de Chelly. Petroglyph panels containing ducks are fairly common on the Colorado Plateau.

page 11 Storage structures are often constructed by wedging them into natural openings in the canyon walls. This unusual natural "cave" near River House contains one such structure.

☾

Gallery One: Cedar Mesa

page 14 & 15 This striking complex in a remote Cedar Mesa canyon blends so well into the canyon wall as to be nearly invisible except when sunlit at certain times of day. The main room block is located behind a masonry screen wall with strategically placed openings for light and ventilation. The result is a beautifully preserved row of decorated rooms constructed of masonry, coursed adobe, and jacal, now threatened by seepage of water and the increasingly frequent and careless human visits.

page 16 The red and white pictograph of this snake is visible through one of the openings in the screen wall (pages 14 and 15). Snakes are common pictograph and petroglyph images, reflecting both the familiarity and reverence the ancient canyon inhabitants had for these reptiles.

page 17 This beautifully carved petroglyph panel is named *Wolfman Panel* for the presence of a small, square-bodied figure with huge hands and feet. The panel includes depictions of planting sticks, a mask, a basket, a yucca plant, wands, birds, a human figure wearing a headdress, and two "lobed circle" symbols unique to Southeast Utah.

page 18 Southeast Utah includes hundreds of canyons, many of which hold cliff dwellings, kivas, and storage structures from the late Basketmaker and Pueblo I, II, and III periods. The alcoves into which they are built continue to spall, in this case revealing fresh red rock and artistic patterns created of calcium deposited by the water.

page 19 These pictographs are found in a small alcove of an obscure canyon on Cedar Mesa in Southeast Utah. It is thought that these target-like drawings are representations of shields used in combat. The pictographs date from the Pueblo II period.

page 20 Kachina Bridge is one of three water-carved geological formations in White Canyon in Natural Bridges National Monument. The monument, established in 1908 by Teddy Roosevelt, was the first in Utah. It is said that he wished to protect these beautiful sandstone bridges from the commercialism he observed while visiting the famous natural bridge in Virginia.

page 21 This small cliff dwelling is distinguished by the unusual natural structure of the sandstone alcove in which it is located. Layers of sand geologically deposited as a wind-blown sand dune, which was then compressed and eroded to produce this unusual effect, created the pattern, which resembles a raging fire.

page 22 Representations of Kokopelli have almost become the cliché symbol of the Southwest. These often insect-like figures may have been representations of the flute-playing *pochteca*, traveling traders who made the rounds of the pueblos, announcing their arrival with a flute.

page 22 This small pitcher was constructed of plain grayware (Chapin Gray) using a shaped stone for the beak of the bird. Such effigy vessels are characterized as Mesa Verde style, with an uncertain construction date (Basketmaker III–Pueblo II). Provenience: unknown. From the Edge of the Cedars State Park Museum collection.

☾

PUEBLOS OF THE ANCIENT SOUTHWEST

page 24 For the Navajo people the Hogan is a traditional house, also used occasionally for ceremonial purposes. This Hogan is on the trail leading to White House Ruin in Canyon de Chelly.

page 26 This site consists of seven round towers, several storage structures, and a kiva arranged in a semicircle on the rim of a small canyon on Cedar Mesa. Below the towers are a productive spring and a cave in the canyon wall. It is estimated that the site was occupied from approximately A.D. 1050–1150.

page 27 Unfortunately "chalked" by previous visitors, this large petroglyph panel contains spiral and concentric circle motifs, many human-like figures, and various plant representations including this yucca.

page 27 Mule Deer (*Odocoileus hemionus*) are often-seen residents of the canyons and mesa tops of the Colorado Plateau.

page 28 Described as a Piedra black-on-white globular seed jar, this pristine storage pottery was found filled with squash seeds (*Cucurbita*). The mouth of the jar was plugged with a stopper made of animal hide (possibly rabbit) wrapped around a human hair bundle. Dated from the Pueblo I period. Provenience: unknown. From the Edge of the Cedars State Park Museum collection.

page 29 The Narrowleaf Yucca (*Yucca angustissima*) is found on dry mesas and slopes throughout the Colorado Plateau. The leaves of this and other yucca species provided fiber for baskets, sandals, and cordage, and fruit that was eaten raw, roasted, or dried for winter consumption.

page 30 Sosi black-on-white ladle bowl. Kayenta style, Pueblo II period. Provenience: unknown. From the Edge of the Cedars State Park Museum collection.

page 31 The Edge of the Cedars Pueblo consists of fifty to one hundred rooms and several kivas, and was occupied from approximately A.D. 750–1150. Water for the inhabitants was obtained from nearby Westwater Canyon, which contains another large pueblo ruin. This site is thought to have been a prehistoric trade center. The nearby present-day cultural center and museum have a wonderful ceramics collection, and exhibit some of the artifacts found during the excavation of the pueblo.

page 32 Pueblo Bonito was first described by Lt. J. H. Simpson, and the first excavations of the site were conducted by Richard Wetherill. Work from 1896–1900 by the second Hyde Exploration Expedition cleared 190 rooms, and further excavation and stabilization were done by Neil Judd and the National Geographic Society beginning in 1921.

page 33 Visitors to Pueblo Bonito are allowed to enter the massive structure and tour several of the room blocks. Extensive study of this site has shown that the structures were often oriented to solar, lunar, and cardinal directions, with lines of sight between the great houses to allow communication. Sites like Pueblo Bonito are still considered sacred to the American Indian descendants of the original inhabitants.

page 34 The Pueblo Alto complex is located on the mesa top north of Chaco Canyon. It consists of Pueblo Alto, East Ruin, New Alto (pictured here), and Rabbit Ruin. The complex is a hub on the Chacoan road system, leading to the interpretation that it was utilized as a commercial center, and perhaps as a market and center for the storage and transfer of goods.

page 35 This prehistoric grand staircase ascends to the mesa top behind Hungo Pavi in Chaco Canyon. It is one of several such stairways, located on the formal ancient roads leading into and out of the canyon.

page 36 Sheer canyon walls often contain precarious hand and foot hold staircases such as this one in Tsegi Canyon near Kiet Siel. These structures attest to the ingenuity, steel nerves, and climbing ability of the Ancestral Puebloan People.

page 37 A monsoon flow of moisture is typical of the late summer months on the Colorado Plateau, one of two annual rainy seasons (snowfall provides the other). These typical afternoon rains are essential to the survival of crops and the continued production of canyon-head springs.

page 39 Aztec Ruins are located on the north bank of the Animas River near Aztec, New Mexico. The name of this complex reflects the popular belief in the late 1800s that these were the remains of cities built by the Aztecs or Toltecs of ancient Mexico. This structure, known as the Western Pueblo, is the largest of twelve structures located in Aztec Ruins National Monument.

page 40 The grinding of corn using mano and metate was most likely done by the women in the ancient Puebloan societies. The tedious nature of this task was remedied somewhat by clustering the grinding stones and bins (such as these at Aztec Ruins) so that the laborers could at least visit during the long hours of work.

page 41 Long House is one of the largest of the "cliff dwellings" in Mesa Verde National Park. It lies in a very large alcove at the head of a small canyon cut into Wetherill Mesa. At the center of Long House is a rectangular great kiva with a raised masonry firebox, two masonry-lined floor vaults, and a masonry-lined sipapu. Room blocks at Long House were up to five stories in height.

page 42 There never was a spruce tree at Spruce Tree House in Mesa Verde National Park (they were Douglas firs), but the name stuck nonetheless. The head of Spruce Tree Canyon contains the strongest known spring at Mesa Verde, which supports an impressive thicket of poison ivy.

page 43 An alcove high in the cliff of a small Cedar Mesa canyon contains a ruin known locally as Eagle's Nest. It is hard to imagine that a habitation structure such as this one would have been built in such an inconvenient location if not for defensive reasons.

page 44 Given the name *Monarch's Cave* by the Illustrated America Exploring Expedition in 1892, this small cliff dwelling dates from approximately 1250. The original masonry is Mesa Verde style and reflects the frequent conflicts of the mid–1200s. The pueblo resembles a medieval castle protected by a defensive wall with loopholes, providing inhabitants with views of the only approach routes. Hastily constructed defensive ramparts altered the site at a later date suggesting drama and further conflict prior to its final abandonment.

page 45 This Bluff black-on-red pitcher is unusual because of its canine effigy handle with inset eyes made of turquoise. It is thought to date from the Pueblo I period. Provenience: unknown. From the Edge of the Cedars State Park Museum collection.

page 46 This macaw feather sash is quite unique in the Ancestral Puebloan world. Mounted on a base constructed of the pelt of an Abert's Squirrel (*Sciurus aberti*), a species native to the modern Four Corners Region, the attached yucca fiber cords are wrapped with over two thousand red and blue feathers from Scarlet Macaws. The fact that macaw feathers were often used to decorate religious objects indicates that this sash was most likely a ceremonial garment. Contemporary Hopi and Zuni dancers wear similar sashes made of red cloth during seasonal Kachina ceremonies. Provenience: Lavender Canyon, Southeast Utah. From the Edge of the Cedars State Park Museum collection, on loan from Kent Frost.

page 47 Wupatki is a Sinagua village consisting of one hundred rooms, which was occupied from approximately A.D. 1135–1195. There is a clear Puebloan influence on this settlement, which includes the masonry style, kiva structure, and the presence of Kayenta-style pottery, as well as the Hohokam-style contribution of a ball court near the pueblo.

page 48 While Wupatki Pueblo is Sinagua, the oval masonry ball court at Wupatki is typical of Hohokam pueblos. No one knows how the game was played here, but a rubber ball was used in the variation played by the Maya, Zapotec, Aztec, and other Mesoamerican peoples, and was likely used here as well.

page 49 The great complex at Paquimé in the Chihuahuan desert of northern Mexico is approximately twenty-seven times as large as Pueblo Bonito in Chaco Canyon. At its peak, it was comprised of horseshoe-shaped, three- to seven-story apartment blocks, public plazas and private courtyards, a subterranean well, agave roasting pits, turkey and macaw nesting boxes, artisan work areas, ceremonial rooms, and a centrally-located ball court.

page 50 Characteristic of Ancestral Puebloan structures such as those found at Chaco Canyon and Mesa Verde, T-shaped doorways are also a characteristic of Paquimé. Some archaeologists think that this shape of entry designated public spaces entered from a plaza area.

page 51 Live macaws and macaw feathers were prized in the Ancestral Puebloan world. While it is unlikely that these birds were successfully bred in northern locations, Scarlet Macaws, native to Western Mexico, were bred on a commercial scale at Paquimé. At or near this macaw-breeding complex, the remains of over five hundred macaws were found when Paquimé was originally excavated by Charles Di Peso of the Amerind Foundation.

page 52 Laguna Pueblo was founded by people migrating from Cochiti and Santo Domingo Pueblos at the end of the Pueblo Revolt. The mission church *San Jose de Laguna* was built in 1699 and remains a dominant feature of the pueblo. Laguna, a sister pueblo to Acoma, is one of the few Keresan-speaking pueblos.

page 53 The depiction of horses in this petroglyph panel clearly places it in the Historic Period following the arrival of the Spanish in 1540. These horses have been carved into an ancient petroglyph panel, with much of the older artwork still visible behind the newer work.

☾

Gallery Two:
Grand Gulch and the San Juan River

page 56 River House pueblo on the San Juan River in Southeast Utah is a well-preserved ruin consisting of eighteen rooms and two kivas. Its architecture is especially interesting because the kivas are built in the Mesa Verde style, but the masonry is Kayenta style. River House has also been called Serpent House because of a beautiful red and while serpent pictograph painted across the cliff above the pueblo.

page 57 The Fremont Cottonwood (*Populus fremontii*), a member of the willow family, is common in the southwest where reliable moisture can be found along rivers and streams. This tree can reach up to ninety feet in height, and five feet in diameter.

page 58 This complex pictograph, dubbed *Baseball Man*, is actually a collection of Basketmaker images that acquired a shield-like addition by an artist from a later culture. The reuse of a site and additions to older pictographs are common. Specific sites seem to hold special significance and often contain rock art from many periods superimposed. In this panel, an earlier image has been purposely modified, perhaps to restore or redirect the power of the earlier image.

page 59 Painted above Jailhouse Ruin are these shield-like images from the Pueblo II–Pueblo III period. These images may represent phases of the moon, or may have familial, social, or religious purposes.

page 60 Turkey feather blankets appear to have been common personal possessions of the ancient Puebloan people, providing warmth much like a modern down jacket. Few examples remain because of the vulnerability of these textiles to decay and the work of insects and rodents. This blanket is complete, with the exception of the loss of down from the feather quills that are wrapped around the yucca cordage that create the textile. Date and provenience of this blanket are unknown, but it is thought to be from the Cedar Mesa area of Southeast Utah. From the Edge of the Cedars State Park Museum collection.

page 60 Upon carbon dating, this Archaic Period, open-twined sandal made of yucca fiber was found to be approximately eighty-three hundred years old. From the Edge of the Cedars State Park Museum collection.

page 61 Storage structures such as this granary are frequently seen in the canyon walls of Cedar Mesa. These small, tight, masonry rooms are thought to have served as communal storage facilities for corn and seeds. Their inaccessibility was probably intended to discourage looting, and their architectural integrity designed to prevent rodent damage to stored foods.

page 62 This kiva at Split-Level Ruin in Grand Gulch is typical of Puebloan kivas throughout the Colorado Plateau. Little remains of the roof of this structure except for Piñon Pine timbers and a little of the shredded juniper bark and adobe ceiling.

page 63 This San Juan Basketmaker site in Grand Gulch contains the two red and white anthropomorphic figures seen here. The clearly visible red figures are precisely superimposed over very faded white figures with tall headdresses, which suggests a renewal of artwork produced at a much earlier time. This panel also contains a birth scene, and these life-sized handprints.

☾

ANCIENT SPACE AND TIME IN THE CANYONS

page 64 The summer sunrise is spectacular through this window in an east wall of Pueblo del Arroyo. This Pueblo contains approximately 280 rooms and over twenty kivas, including an unusual tri-walled structure like those seen at Aztec.

page 66 A frequently encountered petroglyph motif is one consisting of spirals and/or concentric circles. This petroglyph consists of a central grouping of concentric circles, with a total of nineteen ridges. Since the ancestral people were well aware of the cycles of solar and lunar events, this number of turns (frequently encountered in rock art) suggests the lunar cycle of 18.61 years between major standstill events. The extensions of "tally marks" also suggest some type of counting device, which may indicate the calendrical purpose of this petroglyph in Southeast Utah.

page 67 At sunrise on summer solstice, sunlight streams through a small window set in the east wall of the great kiva at Casa Rinconada, creating a moving square of light on the opposite side, which finally comes to rest on a stone recess in the middle of the west wall.

page 68 Fajada Butte stands alone at the confluence of Gallo Wash, Fajada Wash, and Chaco Wash. Near its summit is the solar calculator known as the Sun Dagger that demonstrates the astronomical sophistication of the ancient residents of the Canyon.

page 69 The construction of Chetro Ketl began about 1020, with later modifications through the 1100s. There are approximately five hundred rooms and sixteen kivas here surrounding an elevated earthen plaza.

page 71 A Chacoan great house is built just below Chimney Rock and Companion Rock pictured here. The complex serves as a lunar observatory, marking the major northern lunar standstill with the moonrise framed between the pillars of stone.

page 72 Winter solstice sunrise, as observed near Wijiji in Chaco Culture National Historical Park, illustrates the possibility of constructing horizon calendars from many locations in the Canyon.

page 73 Corner windows can be found at several locations in Pueblo Bonito as well as at Aztec Ruins to the north. Construction of such windows involved some tricky engineering, and it is therefore thought that these had some special significance. While most of these corner openings are interior with no view of the sky, two of these windows face east and provide good views of the winter solstice sunrise. From one of these it is known that at solstice the sunrise casts a distinct square patch of light into the corner of the room containing the window.

page 74 Wijiji appears to have been built in a single stage in the early 1100s. It has a symmetrical plan and contains rooms of uniform size. It is likely that Wijiji was never occupied, adding to the mystery of its construction.

page 77 There is a raised mound near the center of the ruins of Yucca House that once was a great house with two large kivas. From this location, it is possible to see the bare rock "toe" of Sleeping Ute Mountain where, at winter solstice, the sun sets precisely over this unique landmark.

page 78 This solar observatory, not far from Holly Ruin in Hovenweep National Monument, consists of two pecked spirals and one series of concentric circles under a rock overhang. The spring equinox, the summer solstice, and the fall equinox are each marked by a shaft of sunlight that reaches the petroglyphs at these specific times.

page 79 Corn grinding features are common on the Colorado Plateau and include frequently found manos and metates, as well as grinding features such as this one found in a bedrock boulder near Perfect Kiva. Both the orientation of these grinding features, and the apparent inconvenience of their orientation for utilitarian grinding suggest a ceremonial purpose for their construction.

page 81 Perfect Kiva Ruin is a beautiful, stabilized site, located in a deep alcove in Bullet Canyon in the Grand Gulch Archaeological Area. The original ladder from the kiva is on exhibit at the Edge of the Cedars State Park Museum.

page 82 This unusual petroglyph, found on a large rock feature known as Piedra del Sol, in Chaco Canyon, suggests the appearance of the solar corona. While impossible to see with the naked eye, this startling feature may have been visible during a total solar eclipse, such as that known to occur during 1097.

page 83 This set of pictographs can be found on the trail to Peñasco Blanco in Chaco Culture National Historical Park. The painted star and crescent moon may represent the eastern sky just before sunrise, or possibly the supernova explosion in 1054 that created the Crab Nebula. Below this panel is a pictograph that some think is a representation of Halley's Comet, which would have been clearly visible from this site in 1066.

page 85 Within Hovenweep Castle is a room, strategically pierced with loopholes that allow the projection of sunlight onto an interior wall. This arrangement creates a solar calendar of the room, capable of anticipating and marking solstice events.

☾

GALLERY THREE: PROTECTED PLACES

page 88 This remarkable two-story, two-room tower was constructed at the head of a small canyon where a spring is located under the canyon rim. Above the spring a dam was built to hold rainwater, so that, rather than running off into the canyon, the water would seep down through the sandstone to replenish the spring below.

page 89 Long House on Wetherill Mesa in Mesa Verde National Park contains more than 150 rooms and twenty-one kin group kivas. An additional rectangular great kiva lies in the center between the two clusters of room blocks reaching five stories in height. The water supply for Long House came from a strong spring that flowed out from a ledge in the center of the alcove.

page 90 This pictograph is part of a panel found on a cliff-face in the Grand Gulch Archaeological Area. While its purpose and symbolism is unknown, the artwork seems to invite modern-day whimsical interpretations.

page 90 White House (Casa Blanca) was named by Lt. J. H. Simpson who visited Canyon de Chelly in 1849. The name takes note of a conspicuous white-plastered wall in the upper alcove portion of the ruin.

page 91 Spruce Tree House is thought to have been constructed between the years A.D. 1200 and 1276. The cliff dwelling consists of 114 rooms and eight kivas, and is thought to have been occupied by eighteen "kin groups." Spruce Tree House is the second largest of the cliff dwellings in Mesa Verde National Park.

page 92 The Common Raven (*Corvus corax*) is a constant companion in canyon country. As the undisputed genius of the bird world, this animal plots, plays, teases, plays dead, imitates other ravens, and huskily comments on the general behavior of the world around it.

page 93 The silent village of Kiet Siel contains many tall, upright timbers that were carried into the alcove and fixed at intervals between the kivas and habitation structures. While their purpose cannot be determined with certainty, it has been suggested that these might have served as perches for the macaws that were traded here from Mexico and prized by this culture.

page 94 Cutthroat Castle was built during the Pueblo III period like the other villages at Hovenweep. Unlike the other settlements, however, Cutthroat was built across the middle of a wash rather than at a canyon head. This wash contains several still-active springs, marked by the ruins of what once were multi-storied towers.

page 95 Betatakin (Navajo meaning "ledge house") is located in a magnificent, football field–sized alcove near the floor of Betatakin Canyon. This pueblo contains approximately one hundred rooms, but mysteriously, only a single, square kiva. A large pictograph on one wall of the alcove depicts the Hopi Fire Clan symbol, clearly indicating the relationship between the original inhabitants of Betatakin and the modern-day Hopi.

page 96 Cutthroat Castle is found in a remote canyon in Southwest Colorado, and is part of Hovenweep National Monument. This portion of the complex, also known as Horseshoe House because of its shape, originally reached three stories. It contains a tunnel that leads through a crevice from above to a two-story rounded room below the ledge.

page 96 A bird effigy decorates this child's ceramic mug. Further decoration is in mineral paint, in Mesa Verde Black-on-white style. Provenience: Unknown. From the Edge of the Cedars State Park Museum collection.

About the Authors

John L. Ninnemann's photography has been featured in many exhibits throughout the West and Southwest. He has won *Editors Choice* awards in two successive Canon photographic contests, the *Photographic Excellence* award at the Spring 2000 Photographic Arts Show at Larson Gallery in Yakima, Washington, and a Durango Chamber of Commerce special recognition award for his photography in 2003. John lives in Durango, Colorado, where he is a member of the Fort Lewis College faculty and Dean of the School of Natural and Behavioral Sciences.

Stephen H. Lekson is Curator of Anthropology at the Museum of Natural History, University of Colorado, Boulder. Lekson is a southwestern archaeologist who has lead 20 expeditions in New Mexico and Arizona. He is the author of two dozen books and monographs, and more than seventy five scholarly articles and book chapters, and a frequent contributor to *Archaeology* and other magazines.

J. McKim Malville is Professor Emeritus in the Department of Astrophysical and Planetary Sciences at the University of Colorado, Boulder. Kim has also held teaching and research positions at the University of Michigan, University of Oslo, and University of Sao Paulo. He has published six books and more than 120 research papers in the areas of Astrophysics and Archaeoastronomy. He continues to study ancient astronomy in the American Southwest, Egypt, India, Tibet, and Peru.